TEXAS DAMES

★

SASSY AND SAVVY WOMEN
THROUGHOUT LONE STAR HISTORY

CARMEN GOLDTHWAITE

Charleston · London

THE
History
PRESS

Published by The History Press
Charleston, SC 29403
www.historypress.net

First published 2012

Manufactured in the United States

ISBN 978.1.60949.812.2

Library of Congress CIP data applied for.

Texas Dames *and its stories of gallant Texas women is dedicated to the two Texas women who made it possible.*

To my mother, Texas native Katherine Fitch Goldthwaite, who reared me with boundless love and laughter and inspired me with stories of family, creating vivid pictures of resiliency, strength, courage and the good humor of Texas women. She fed the curiosity that led to these stories.

To dear friend SJ Mackenzie, who arrived in Texas this generation, my first reader, who tended the home front and ageing family so that I could trek the highways and byways of Texas gathering these stories.

CONTENTS

PREFACE

Across the sandy plains and hills of Texas, through the timber and the forests, the rocky hills and mountains and the grassy reaches, Texas women stamped their imprint. Maybe we know them. Maybe we don't.

But that's what *Texas Dames: Savvy and Sassy Women Throughout Lone Star History* is here to show—their lives and their legacy—much of what today's Texas woman enjoys without question. But we weren't there when Spanish and Indian women greeted and welcomed the Europeans or when Mexican women wielded their wealth from ranches to support the Texas independence cause.

We were not there when immigrants, only some of them literate, waded ashore to further the dream of owning land of their own. On the heels of that dream rose the zeal to educate their young and provide a faith that would hold them steady on life's course.

We were not there when women performed heroic deeds to save a community or a child. Nor were we there when women who were shunned took up residence with the respectable folk and left their mark on the gaming tables, soldiers' camps and mule trains of Confederate contraband cotton. Some were heroines. Others wore the crown of shady ladies. Some started life in Texas with sullied reputations and grew into renowned women. More than one was a spy. But nearly all exhibited similar strands of courage and determination to wrest a country, a state and a region from the wilds.

These are the Texas Dames, women who sallied forth commanding great ranches, building towns, directing banks, controlling bridges and operating mercantile centers. These Dames broke gender and racial barriers in education, ministry, banking and commerce, entertainment, the arts, athletics, politics and medicine.

Today's stars of stage, screen and pen might well trace their artistic roots to these Texas Dames. Today's Olympians continue to advance women's athletics

based on the initial accomplishments of a little tomboy from Port Arthur and Beaumont. Today's astronauts fly higher and faster in the military and in civilian life, an acceptance built on the gutsy gals of San Antonio who would teach World War I aviators and fly the U.S. mail but could not join the army, a fact tempered only mildly by the WASPS of World War II. These women flew and helped the fellows train but did not participate in the spoils of victorious war until most were in their seventies and eighties.

Women today populate the U.S. Senate and the House of Representatives. They wield the gavel in legislative halls, courtrooms and municipal chambers. But long before them, before women won the right to vote, a doctor's wife from Marble Falls won the reins of city government.

Just as today's Texas woman enjoys the pathways cleared of many brambles by these Texas Dames, this scribe owes much to the research and the writings of other female Texas writers and historians, such as Lou Halsell Rodenberger and Sylvia Ann Grider in *Texas Women Writers*. Others include Jo Ella Powell Exley, in *Texas Tears and Texas Sunshine,* and Sheila McElroy, in *Red River Women*. These and many more have been bringing to light the long dimmed stories of Texas Dames and their legacies.

And then, in conversations with friends, family, neighbors, café owners and community historians and leaders, many other stories of these Dames were brought to light. For countless others who left a silent record, the courthouse documents of wills and land transactions served as sources of information and evidence of their lives. The research of folklorists and historians has also contributed to the tales of the Dames. Newspapers, both old and new, offered other stories, as have the historical societies and publications from around the state.

To these well-known and little-known women—the Texas Dames—we owe a debt of gratitude for weaving the textile of Texas into the society we know today. When you read the stories of these Dames, pause with me and wonder what life would be like today without the mothers, grandmothers, great-grandmothers and so on who have pulled together families and communities and who have broken trails into disciplines once barred to women.

Here are their stories, from early Tejas to the mid-twentieth century.

ACKNOWLEDGEMENTS

No work of this nature is carried out alone. Librarians and archivists as well as museum directors and curators across the state lent time and talent in the pursuit of obscure facts and people. My thanks to them is boundless. First on the list would be the fine women—Tammy Schrecengost and Nancy Raney—of the Heritage Museum in Big Spring, who introduced me to the first woman I researched through papers, photographs, the ranch and interviews with people who had stories to share.

Volunteers at the Falls on the Colorado Museum guided me to an amazing "first in the nation" story. W.L. Pate of the Babe Didrickson Zaharias museum walked me through the life of this preeminent golfer and female athlete. Newspaper editors in communities across the state provided good leads on gallant women of their areas. In Brownwood, word of mouth from the library to the newspaper to the Brown County Museum of History put me in touch with Alexia Hueske Bieniek, who had researched and written about this town's uncommon woman and was willing to share.

In my hometown, Shirley Apley, retired senior librarian of the Fort Worth Public Library, Genealogy/History Department, never seemed to tire of tracking down the stories of women in North Central Texas. Southern Methodist University (SMU)'s DeGolyer Library came through with photos and stories of a Dallas legend.

Brenda McClurkin, historical manuscripts archivist at the University of Texas at Arlington Special Collections library, possesses an uncanny memory for names and research projects and called when something of interest turned up.

To each and all, a hearty thank you for your excitement and your diligence.

Chapter 1

AT THE GATEWAYS TO TEXAS

When the Europeans set foot in Texas, Indian women greeted them and facilitated interpretations between the Spanish and Indians and then the French, Spanish and Indians. Spanish, Mexican and Canary Island women proceeded to overlay their cultures of riches on the Indian land as the country became first a Spanish province and then the northern province of Mexico. At each step, from that first translator, women emerged in the leadership and settling of Texas. For generations, the Spanish-named Texas women's stories fell silent in the backlash of Anglos after the war with Mexico. However, Anglo women, beginning to populate Texas, would build a republic and a state in the deep footholds notched by these Indian and Spanish-speaking women they did not know, women who had welcomed newcomers and made the wild country ready for later women and their families. These "facilitators" established or enabled churches and churchmen, schools, villages and towns; extended hospitality to all manner of strangers; exercised nuances of politics and business; and embraced the arts and festivities.

SHE AIDED PRIESTS, SAILORS AND TRADERS

Angelina

Her name lingers on maps of Texas today, the only woman with a river named for her, Angelina. A river, a forest and a county bear her name. The river is the oldest. On the French maps of the Gulf Coast of Texas, the Angelina River showed up in 1769, named for a lithe young Indian woman whose tribe welcomed strangers.

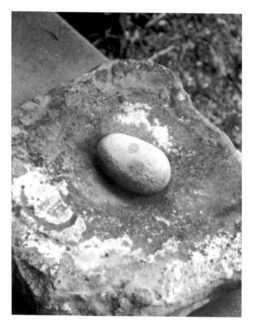

Indian corn grinder that Anglo women picked up and used when they settled on the frontiers of Texas.

As a young woman, Angelina midwifed communications among her people, the Hasinai branch of the Caddos, and the French and Spanish who challenged each other over this territory between the rivers.

When Spanish missionaries wound their way through the tangled forest and approached the Indians, Angelina seemed to be drawn to them. The priest who met her wrote of meeting "an Indian maiden with a bright intellect and possessing striking personal appearance...expressing a desire to learn the father's language."

That padre, a Spaniard, had arrived with the governor and soldiers to establish Mission San Francisco de los Tejas, the first in East Texas. Angelina and her riverbank people welcomed the expedition with shouts of "tayshas!" meaning friend or ally. As was the custom for the Hasinai, they spoke and wept at the sight of strangers.

Although puzzled by the tears, the Spaniards enjoyed the friendly welcome and adopted the greeting, pronouncing it "tehas." Soon they applied this term to other friendly natives, and then this greeting became the province's name, Tejas, forerunner to today's Texas.

However, for the missionaries over the next few years, both language and cultural differences proved to be stalwart barriers for conversion of the Indians and adaptation of the Europeans' ways. While Angelina was gifted in picking up the Spanish language and interpreting between her people and the friars, the priests struggled to learn the tongue-clicking dialect of her kin. In their zeal to convert the Indians, the friars showed no respect for the Caddo religion.

This and other events challenged and interrupted the Caddoans' friendship with the newcomers. A chieftain kicked the Spanish out of the Caddo lands because of their religious intolerance, the cruelty to women practiced by the soldiers and the introduction of smallpox, which killed three thousand Indians.

When the Spanish left, though, Angelina's people continued welcoming others drifting in from the coast and west across the Sabine River.

The Hasinai favored these Frenchmen, believing them to be friends and allies, or "taysha," since they came to trade, not conquer or convert. When adventurer Robert La Salle came through, so hospitable were the Hasinai that several of his men deserted, remaining with the Indians on the banks of the river. With Frenchmen in her village, Angelina picked up their language, too.

By 1715, commerce—not religion—eventually bridged the chasm between the Spanish and Angelina's people. Trade had increased between them and between what the Indians called "other Spaniards," or the French. The Royal Spanish spurned the French and chafed at any movement of them into Texas.

Spurred on by a growing French presence in these timberlands of East Texas, the Spanish once again journeyed to the Caddos, this time to set up several missions and presidios, including *Mission Nuestra Senora de la Purisima de la Concepcion*, which became the first capital of Tejas.

Angelina had grown up by then, and a new generation of priests wrote that "a sagacious woman, baptized and learned of the Spanish and Tejas languages," served as interpreter.

Described as having a strong personality, gifted with language and sensitive to the needs of others, Angelina's legend has followed as many twists and turns as the East Texas river that bears her name, a fitting tribute to the woman whose skills with languages and interpretation enabled the spread of trade and Catholicism in this area known as New Spain.

In every story about Angelina, she was said to welcome strangers without fear. A common tale is that a wounded and abandoned French officer stumbled into her village, where she took care of him. When he recovered, she sent her children to guide him through what has become known as the Big Thicket to join his countrymen at Natchitoches, Louisiana. That young Frenchman later married a Tejas-born Spanish woman and established a large-scale trading fort across the Sabine River from the provincial capital *Mission Nuestra Senora de la Purisima de la Concepcion*.

By her intelligence, friendliness and skill, Angelina furthered communications, trade and religion among the three cultures of the Caddo, Spanish and French, extending the hospitality of her people to all strangers and setting the precedent for Texas' friendly greetings.

WITHOUT HER, NO TEXAS?

Maria Gertrudis Perez

Whether cajoling her father into tales of Indian battles while sitting on the porch of the Royal Presidio or dancing with handsome, sword-dangling Spanish

The Alamo, where the Mexican Army defeated a small band of revolutionaries holed up within the San Antonio mission's walls. "Remember the Alamo" became the battle cry for Texian revolutionaries. Across the street from where Maria Gertrudis Perez grew up, dancing with Spanish soldiers, the Alamo serves as a reminder of the cost of independence and the state's "Six Flags" history.

officers from the Alamo, Maria Gertrudis Perez enjoyed a life of privilege in the Governor's Palace of San Antonio. Born in 1790 to Canary Island parents, Spanish loyalists brought here to tame the wild lands for Spain, she would become the first First Lady of Texas and interim governor. In those roles, she opened doors to Anglo settlement.

Maria's home sprawled near LaVillita, across from the Alamo. The Spanish officers garrisoned there were handsome suitors for this teenager who had sailed to Spain for her education and then returned from time to time for the latest fashions.

Although well schooled and while subject to Spanish law, Maria could own property, inherit, buy and sell on a par with any man—an independent woman under the law—in matters of marriage, her father reigned. Her Spanish custom required an arranged marriage. She balked. Her father's choice was the governor, a man older than him. A devout Catholic, Maria turned to prayer, at last agreeing to marry Governor Don Antonio Bustamente and becoming Tejas' first First Lady.

The governor recognized her intelligence and skill in managing people and property and her social acumen. He called on the First Lady, instead of his officers, to run the provincial government when he was away from the palace on long trips to Mexico City or out west fighting Indians. The first time he authorized her to run the government at San Antonio, Maria was eighteen.

"She conducted affairs of state in grand style and reviewed the Royal Spanish troops as expertly as Queen Isabella," according to reports of this transfer of power. Troopers at the garrison called her "La Brigaviella," or Mrs. Brigadier General. She accepted their salutes and honors in the governor's absence.

Fashion-minded, when she conducted military reviews, the interim governor rode a spirited horse with a handsome tooled sidesaddle, bedecked with silver. A long-skirted, dark green velvet riding habit flowed over the saddle. Her military jacket was heavily embroidered in gold thread, and she topped off the ensemble with a plumed hat.

But on Saturdays, she turned from matters of state to caring for the poor of La Villeta. She walked to the church to "dispense alms and favors to the needy," a cause she would continue for her lifetime.

Equally at home in the ballroom of the Royal Palace, the boardroom or the parade ground, Maria hosted visitors from many nations, moving among them, easing tensions and facilitating friendships while plans for the future of Texas were made. She entertained visiting royalty and visiting land speculators such as Moses Austin, who sallied in with empresario plans— plans to finance, recruit and populate Texas with colonies of citizens from the United States and abroad. Maria eased him into conversations with the people he needed to approach.

Because of her introductions, Austin and his son, Stephen F. Austin, later known as the Father of Texas, obtained colonization grants to settle Americans here before Maria's life and influence would change.

Soon her husband died. Mexican Revolutionists held San Antonio captive in 1813, beginning a rebellious period of Mexicans versus Spaniards. Hostile Indians surrounded the town. Maria's father's troops rebuffed the rebellions, and he became governor in 1815. But a year of drought and withering crops brought high prices for trade goods, desolating the trading center's economy, while creating more opportunities for Maria to give of her fortune and more rebellions. Next, a flood drove more families into LaVillita. Throughout, Maria assisted the poorest residents.

But in 1821, a bitter blow fell. The Spanish flag over Texas came down for good when Mexican Republican forces defeated the Royal Spanish. By then, the Austins had their grant and had begun colonizing eastern sections of Texas.

Doña Maria Gertrudis Perez, a proud Canary Islander, loathed the Mexicans. She rebuffed attempts to socialize. She did not accept Mexican governmental rule of her land.

She kept quiet, though, for fear of reprisals to the Frenchman she had married and the son they had. Only at her death and the reading of her will could the depth of her resentment be seen. As benevolent as Maria Gertrudis Perez

Bustamente had been and as wealthy as she still was, she left not a penny to the poor. She feared Mexican officialdom would gain instead of the poor.

Yet, perhaps she had helped birth her most lasting revenge against Mexico—Anglos colonizing Tejas. What she had begun as first lady—paving the way for American colonists—soon led to the Texans' war against Mexico to shake off the Mexican regime and form the Republic of Texas. Although Maria did not live to see this rebellion, the winds of war had begun in 1832, the year she died.

Silver Trail Rancher Stirred Myths and Feuds

Juana Pedrasa

Juana Pedrasa crossed the Rio Grande near present-day Presidio, the Chihuahuan Desert. A twenty-one-year-old widow in 1821, she purchased a vast spread. Under Mexican laws, a woman could buy and sell land, own land independent of fathers, brothers or husbands. Soon, however, that would change.

Her selection of tanned, unbroken land could have been made for several reasons: she had family in Paseo del Norte and silver deposits were present, but, most importantly, the Chihuahua Trail, or the Silver Trail, wound through her ranch. She had eyes on increasing her fortune from the fruits of this shortcut

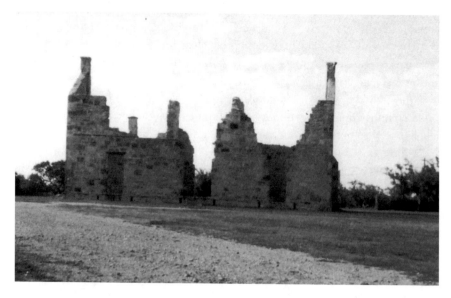

Fort Clarke perches on the San Antonio to El Paso road near Juana Pedrasa's purchase.

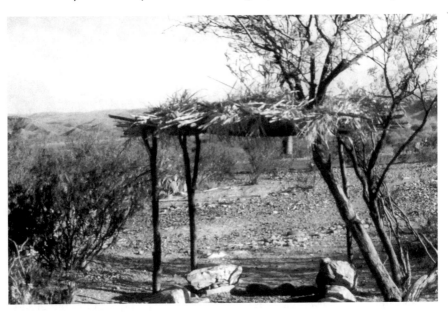

Jumano Indian shelter on the Big Bend, in a high and dry area with no shade in the Chihuahuan Desert.

between San Antonio and Chihuahua, Mexico. Along it rumbled mule trains of supplies from San Antonio and silver from Mexico's mines. Out here, Juana celebrated arrivals with fiestas and barbecues, whether it was traders with imported finery or young men from the States with armies of Mexican mule team drivers.

Her prime border location was ripe for opportunists, and Juana attracted one, Ben Leaton, a comanchero, meaning that he swapped guns, liquor and ammunition that he and his men had stolen from settlers and adventurers to Apaches for mules they had stolen in Mexico. Juana married him. She wanted wealth, and she wanted Ben to get it for her. At her juncture of the trail, Juana fixed up crumbling ruins of an old mission to become her lavish, sprawling castle, a high-walled, armed fortress, the first private fort in the region, and named it Fort Leaton for her husband. The Pedrasa land now was his fort and ranch. From here, her husband ruled the only settlement between El Paso and Eagle Pass.

After moving into the forty-room adobe fort, Doña Juana would rock on the porch that faced the Rio Grande and gaze across the border river to El Cerrito de la Santa Cruz, a rustic stone chapel that held three crosses. The legend along the river is that these crosses possessed a spell that "kept the devil in his cave."

From her rocking chair, Juana would survey her domain and spot the dust clouds that forecast arriving visitors, certain to send her into a flurry of activity. She would welcome these travelers and traders with sizzling barbecued goat

and bubbling pots of beans, creating a festival air no matter whether the visitors were Indians, Anglos or Mexicans. Juana Pedrasa and Ben Leaton prospered, and three little Leatons—two sons and a daughter—started life on the premises of the festive fort.

For years after Texas' independence from Mexico, Juana did not know that the political change would cost her the Pedrasa purchase. She and Ben had supported Texas's independence, yet the new government's English laws replaced Spanish land and inheritance laws. The republic's new laws created a sea change in women's rights to property that Juana did not discover until Leaton was shot and killed on a trip to San Antonio. Now living under Anglo law, and because she had married Leaton, Juana's ranch and fort were his and his heirs, not hers. Although she could no longer own the ranch or Fort Leaton, she could manage it for their sons, Ben Leaton's heirs, and did so until she married another comanchero.

Her prosperity waned, however, as army trains coming west brought brisk business initially, but eventually put a damper on bartering with the Indians for stolen goods. She and her new husband made bank notes. When they could not meet those, people stood by, eager to snag Juana's choice real estate, known to harbor silver deposits. In this time and place, guns—not paper—collected debts and wrung out foreclosures.

Widowed again, and this time dispossessed, Juana moved into Mexico, where her children matured. Her sons and grandsons reached manhood with a long-standing hatred of those who had moved them out, and they nurtured a vendetta to reclaim the Pedrasa purchase. Along the border, for nearly a century, feuds broke out between generations of Leaton men and the families they loathed. The land title never was cleared, nor returned to Juana's people.

A family who later owned and lived in the hacienda at Historic Old Fort Leaton reported that on occasion, on the porch overlooking *El Cerrito de la Santa Cruz*, an empty rocking chair would creak back and forth, unoccupied. The latter-day resident said, "Doña Juana comes back in death to claim her adobe castle on the Rio Grande."

Chapter 2

WOMEN OF THE LAND

1822–1953

M^{ost} women arrived with husbands or families, but many survived alone to
farm and ranch their land in the republic, acquiring land and livestock.
Alone or with their husbands or sons, they drove cattle, horses and mules to
market—New Orleans in the republic days, Kansas in post–Civil War years. A
sheep rancher's prize wool brought the Boston market to her to auction from her
ranch out near Menard. But all succeeded in building homes, educating families
as first-generation settlers on what once had been Indian land. Most created an
agricultural legacy that continues today, and many became so successful that
their influence spilled over into towns, schools and churches.

IRISHWOMAN CHALLENGED SAM HOUSTON

Peggy McCormick

Margaret "Peggy" McCormick sailed into Galveston Bay with her husband and
two sons in 1821, members of Austin's colony known as the Old Three Hundred.
They bumped across the sandbars in a rickety boat from New York and then
walked overland, hauling their meager supplies to a league and a labor—a
league for ranching, a labor for farming, or a total of over four thousand acres.
Labor (pronounced "lah-bór") was a unit of land under Spanish and Mexican
land records and measurement.

An Irish family, the McCormicks raised cattle on the land between Buffalo
Bayou and the San Jacinto River. Peggy's husband named a marsh lake for her,
Peggy's Lake, before he drowned in the bayou in 1824. But Peggy continued to
ranch her land and joust with those she felt overcharged or cheated her. Her

Texas' longhorns birthed the cattle industry in Texas because of the beeves' tolerance for heat and drought. Peggy McCormick, as did most early ranchers, started her herd of these leggy beeves by rounding up strays left behind by Spanish missionaries.

squabbles, mediated by Stephen F. Austin, prompted him to write, "I wish these colonists would get along with each other."

A dozen years later, Peggy sided with Austin in loyalty to Mexico, not joining the Texas Revolution until he did. Then, she let her older son enlist to ride as courier between President David G. Burnet and General Sam Houston. In flight from General Santa Anna's threats to "kill all Anglos," Peggy and her younger boy crossed the Sabine River into Louisiana for protection in the United States.

When she got word that the Texians had won, she headed home, arriving three days after the battle. On this day, April 22, 1836, as far as she could see on the rolling coastal plain, normally covered with spring hyacinths, her livestock had been scattered or butchered. Bodies of Mexican soldiers sprawled across the doorstep to her two-room dogtrot cabin. Corpses lay deep across her little marsh lake, Peggy's Lake.

In her absence, Peggy's McCormick League had played hostess to the Battle of San Jacinto, the place named for the bountiful hyacinths. The bodies of over seven hundred Mexican soldiers lay among the hyacinths just beginning to bloom, their scent obscured by the stench of death.

Peggy marched over to Sam Houston's command tent. "Get these stinkin' Mexicans off my land," she said.

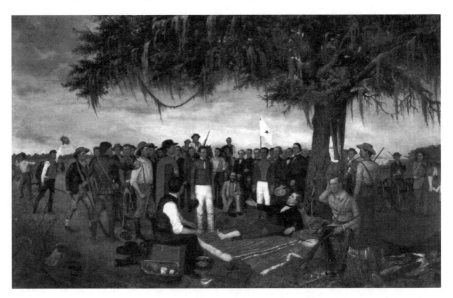

General Sam Houston, soon to be president of the Republic of Texas, rests from a bullet wound beneath a massive oak on Peggy McCormick's League. The Battle of San Jacinto, waged on her land, delivered independence from Mexico to the Texians, or Texans, as they would be called after the war. Peggy confronted Houston at that spot. *Surrender of Santa Anna* shows the wounded General Sam Houston. *Artist: William Henry Huddle, 1890. State Preservation Board, Austin, Texas.*

"Why madam, you'll go down in history," Houston said.

Not impressed, she demanded the removal or burial of the dead. Neither Houston nor the captured Mexican general Santa Anna would issue the order. So, it fell to her. First and foremost, Peggy was a "stock raiser," as she called herself, and needed to repair her land so the cattle could graze. She, her sons and her one slave rounded up her remaining cattle and penned them away from the carnage until they could bury the dead. Houston ordered the army headquarters to be moved upstream of the fouled air.

From her Mexican neighbors in the years before the war, Peggy had learned to ranch on horseback, capturing horses along Mustang Valley, which stretched behind the McCormick League. Tough and determined, she not only survived the harsh times, but also succeeded in building the largest ranch in what became Harris County.

For eighteen years after Texas' rebellion, Peggy rounded up cattle to grow her herd. In the years before, she had trailed her cattle through the dangerous outlaw land of the timbers, along the Atascocita Trail to Louisiana. Now with shipping restored—and without the Mexican tariff—she sent her herds to market by steamboat.

While she stocked her sizeable ranch with cattle and horses, the surveyors and tax assessors of the new republic redrew her land lines into the marsh, the subsided land along the San Jacinto River. Land zealots and war veterans coveted her high ground, the good pastures, and the sheriff and tax collector conspired to strip her of all but fifty acres around her dogtrot cabin.

Since Peggy marked her documents with her "X," chances are she did not know of these shenanigans. And she did what ranchers do today when they need cash when beef prices are down. She sold land; however, she sold parcels that no longer belonged to her.

Those deals, thwarted by the contested titles resulting from multiple sales may have been her downfall. For, rather than being known as the hostess of the Battle of San Jacinto—going down in history as Sam Houston proclaimed—she died in a house fire that neighbors called murder, and that's when her son learned of the swindles, too late to recapture them.

Today, Peggy McCormick's bit of history remembered can be found on some Texas maps that call a sandbar "Peggy's Bar" for the little marsh lake that her husband named Peggy's Lake, swamped and buried by the 1900 hurricane.

CREEK WOMAN SETS LEGAL PRECEDENT

Rebecca Hawkins Hagerty

Shortly before Texas' War for Independence, a young Creek Indian woman, Rebecca Hawkins, sashayed into Nacogdoches with her husband, a half-breed Creek and business and scheming partner with Sam Houston.

A string of Indian villages from Nacogdoches to the Red River, like "beads on a necklace," dotted the route called the Cherokee or Trammell Trace. Hawkins's and Houston's scheme to relocate five thousand Creeks into this land—already feeling crowded to the Cherokees and the whites—ignited tempers, and Hawkins lost his life.

Rebecca, who grew up the protected niece on the plantation-style land of her uncle, the Western chief of the Creeks, found herself with two little girls and the Refuge Plantation between Port Caddo and what would become Jefferson, Texas. In the first year she operated Refuge (1836), she brought the cattle and cotton plantation into the black with her slaves and some Creek family members.

Meanwhile, a fellow named Spire Hagerty had spied the winsome woman and probably eyed her lush acreage. It wasn't too long before he proposed and then proposed that he run Refuge. They married and he did, and they moved to his Plantation Phoenix near Marshall, Texas.

It was a tumultuous marriage because old Spire Hagerty had a fondness for the spirits, and when he drank, he raged. On many an occasion, Rebecca swept up the girls and left home. And then a son was born. Soon after, on another of his rampages, Rebecca left, this time for good. She sued for divorce, but Spire refused to acknowledge paternity for her son. Truth be known, when she left this time it could have been for the love of another, because she did not protest his charges of infidelity.

What she did protest, though, was his intention to disinherit the boy who carried his name. Rebecca moved back to Refuge and borrowed the money from some Marshall bankers to hire a Shreveport, Louisiana law firm. The bankers respected her business practices, granting her the first loan to a woman in that area of Texas, and the lawyers won her case: a child born while the marriage was intact was the child of the couple, codifying Texas' family law.

Spire died before the divorce, leaving Rebecca with two plantations to manage, which she did rather handsomely. She shipped cotton and cattle out of Port Caddo, and one invoice reports she imported these items from New Orleans: "Half a dozen lobster, Brandied cherries, Peaches and pears, a keg of almonds and a Demijohn of old brandy."

Lake Caddo, where the eastern Port Caddo was located, stretched between Texas and Louisiana, the only natural lake in Texas. Rebecca Haggerty shipped cotton and cattle by steamboat across this lake and to New Orleans and received staples and luxuries on the return voyage.

Over the years, she grew her original estate to over 3,200 acres by buying up the farms of cousins, aunts and uncles who bought land here but chose to return to the Creek home in the Indian Territory, where they continued to sell slaves to Rebecca until, in 1860, she was listed as "one of Texas' richest citizens and largest slaveholders…Fifty-four Texans claimed one hundred or more slaves in 1860…Rebecca the only woman…with 150 slaves."

Wheeling and dealing, borrowing and repaying loans with the next crop, Rebecca—with her Indian blood, which she never hid—stirred rumors that ranged from slave claims of poisoning to the society of Marshall that claimed her "the grand dame of southern living."

Protecting her plantation wealth, Rebecca sided with the Confederacy during the Civil War. She sold cattle and hogs to the Confederate Commissary and lost money. Her receipts are marked "not paid for want of funds." During the last year of the war, she turned in "almost $80,000 'old issue' banknotes" for currency valueless after the war.

Without slaves after the war, she employed Creeks from the Creek Nation but continued to lose money. Yearning for home and family, her trips to Oklahoma increased in frequency and her stays lengthened. After her son's death—caused by drinking, like his father—Rebecca Hagerty died on one of these extended trips to Oklahoma in 1877.

THE QUEEN OF TEXAS TRAIL DRIVERS

Amanda Nite Burks

A first-generation Anglo Texan born in the woodlands of Angelina's country near Crockett in 1841, Amanda Nite would be a part of the taming of the "wild horse country" of South Texas. She chronicled those times in her diary and letters.

Married at fifteen to Bud Burks, they ranched in East Texas until after Bud returned from the Civil War. Meanwhile, she had buried their two children. So when Bud told tales of South Texas and wanted to move, Amanda agreed.

They drove horses and cattle to Banquette, Texas, the "wild horse country," she wrote. "These were happy years for we had some good neighbors and a jolly crowd of young folks always around."

Like other ranchers after the war, Bud would drive their cattle north. A day out, though, he sent for Amanda.

"In my little buggy drawn by two good ponies, we overtook the herd in a day's time," she wrote.

The weather often figured in Amanda's writings: "… delightful until we reached Central Texas. Some of the worst electrical and hailstorms I have ever witnessed were in this part and also in North Texas. The lightning seemed to settle on the ground and creep along like something alive."

Near Meridian in the rain and hail, she wrote, "I got back in the buggy and sat there cold and wet and hungry and all alone in the dark. Homesick! This is the only time of all the months of my trip that I wished I was back at the old ranch at Banquette."

In Fort Worth, she said, "we waited for the Trinity River to fall low enough to cross our cattle. I counted fifteen herds here waiting."

Crossing the Red River, she added, "We seemed to have left all civilization behind… no more fresh fields. The sun was so blistering that we hung a cloth inside the top of my buggy to break the heat that came through."

Traces of the old "Kings Highway," or El Camino Real, linger, the wagon ruts visible on the road that ran between San Antonio and Natchitoches, Louisiana, the highway over which the opulence of wealthy Spanish loyalists like Maria Gertrudis Perez and Patricia De Leon traveled. This section is near Crockett, Texas, where Amanda Nite Burks grew up.

A stampede she described as "horrible yet fascinating sight. Frantic cowboys did all in their power to stop the wild flight, but nothing but exhaustion could check it. By working almost constantly, the men gathered the cattle in about a week's time."

She described another peril they experienced. "A prairie fire ran us out of camp before breakfast. We escaped by fleeing to a part of the plain, which had been burned before, called a 'burn' by people of that section to discourage Texas cattle from lingering."

After three months along the Chisholm Trail, they neared Newton, Kansas, and planned to wait for rising prices. But winter arrived first. "Many of the young cattle lost their horns…blocks of ice had to be chopped in order that the cattle could drink." She added, "Bud decided it was time to sell and return to Sunny Texas. He met with no discouragement of his plans from me, for never had I endured such cold."

Amanda left Kansas in December, as she wrote, with "a bucket of frozen buffalo tongues as a souvenir. for my friends in Texas. I came home healthier than I'd left nine months before. What woman, youthful and full of spirit and the love of living, needs sympathy because of availing herself of the opportunity of being with her husband while at his chosen work in the great out-of-door world?"

Five years later, the Burks moved to Cotulla. Fences had come to Banquette. "When Mr. Burks came home he told me he had found a place with plenty of wood and water, as I was always grumbling about the scarcity of both at Banquette," she wrote.

They named their new spread "La Mota, a grove of trees," she wrote. Soon, Bud fell ill and asked Amanda what she would do.

"What do you want me to do?"

"I want you to remain right here," he said. He further advised her to sell the horses but keep the sheep. "I feel you can run a sheep ranch as well as I." He died in January 1877.

The next fall, Amanda began selling the horse herd, including some of the first polo ponies to leave Texas for New York. She continued sheep ranching—profitable in the late 1870s—until barbed wire fencing closed the open range, and she switched back to cattle.

Amanda enlarged her spread from its initial four sections, or 2,560 acres to 43,000 acres, home to over three thousand head of cattle, and continued managing La Mota until her death at ninety-two in September 1931. Amanda Nite Burks is buried in the La Mota cemetery alongside Bud, and the ranch remains in family hands.

A native Texan and a trail driver, she is celebrated as the "Queen of the Trail Drivers Association" in San Antonio.

Sheep Queen of Texas

Johanna Wilhelm

Johanna Carolyn Prugel Wilhelm held onto her native German language and her homeland's Lutheran religion, and she counted her flocks with rocks while she built an empire on the Edwards Plateau.

A good daughter, so they say, Johanna denied her heart. Instead of marrying her sweetheart in Konigsberg, New Mark, Germany, she married her family's choice, a soldier who had completed his tour of duty.

At seventeen, she and Johann Wilhelm exchanged vows November 30, 1868, in the church where Johanna had been baptized and confirmed. For her honeymoon, she marched up the gangplank of the ship that would carry her, Johann and their families to America.

Two weeks later, she set out for Texas from New Orleans by ox train.

Johanna worked alongside her husband farming and raising livestock on rented land in Washington County. They worked hard and enlarged their herd. Ten years later, and with five children, they moved to Camp San Saba on the river while they established a new spread between Menard and Brady. The Wilhelms purchased 1,600 acres for fifty cents an acre. On the frontier, without law enforcement and only occasional patrols from distant forts, Comanche raids and rustlers often depleted their cattle herds.

Yet, over time, they prospered, ordering lumber from Austin for the house at Pecan Springs Ranch near Menard. Traveling craftsmen, particularly stonemasons from Germany, were hired to cut and lay the stones. The family moved into the new house in 1881.

When Johanna and Johann settled there, they "traveled long distances under undesirable conditions" to church and made the trip "several times a year." The Lutheran pastors traveled to the ranch for "weddings, baptisms and to minister the Lord's Supper."

Indian raids ceased in the 1880s, leading the Wilhelms to upgrade their range cattle with Hereford and Durham bulls and then add sheep, raising Delaine and Merino breeds. Cattle rustlers still plagued them, though. While recovering some stolen cattle, Johann was killed by a man "implicated in the theft." Some say Johann was poisoned by the bait he carried for the wolves that preyed on the lambs.

Johanna, a widow at forty who spoke no English and depended upon her children to interpret for her, draped a black cape around her shoulders, a cape that became her traditional garment, and took charge. She named her twenty-year-old son, her oldest, ranch foreman.

A cattleman of the time wrote, "In those trying days, had it not been for her flocks of sheep, she said she would have been forced to retire from the livestock business...rustlers stole all her cattle."

Her son, the ranch foreman, was killed, either by horseback accident or rustlers. She hired a new cattle foreman and named her next son, a sixteen-year-old, to be the sheep boss.

"For years," the cattleman said, "she was forced to go on the range with her babies and watch the flocks to prevent wolves from carrying off her only source

Located between Brady and Menard, almost the geographical center of Texas, Johanna's ranch shows the rock-hard land and dry land agriculture of the region.

of revenue." Alongside her sons, Johanna herded her flocks. Until her health failed, she "never missed directing the shearing of the sheep."

Paying from seventy-five cents to three dollars an acre, between her husband's death in 1890 and her own in 1921, Johanna grew Pecan Springs Ranch from the initial 1,600 acres to over 40,000 acres. On that limestone countryside, she also expanded her cattle and sheep herds, earning an enviable reputation in the wool industry.

Buyers from mills in Boston traveled to Pecan Springs Ranch to bid on her wool, known as "Wilhelm wool" because of its "high quality and long staple." In 1912, the wool industry paid the highest price "for Wilhelm ranch wool over all competitors in the Southwest," according to the Southwestern Sheep and Goat Raisers Association newsletter and several letters in the Wilhelm papers.

In 1900, it is said that she ran between ten and fifteen thousand sheep, goats and cattle, marketing some five thousand sheep each year and earning her reputation as "the sheep queen of Texas," the "first woman to have such numbers of sheep in the state."

A stockholder in the Wool Growers' Central Storage Company at San Angelo, Johanna held interests in several banks. She was described as "kind, considerate and charitable…loved by all who know her and admired for her life record of meritorious achievement."

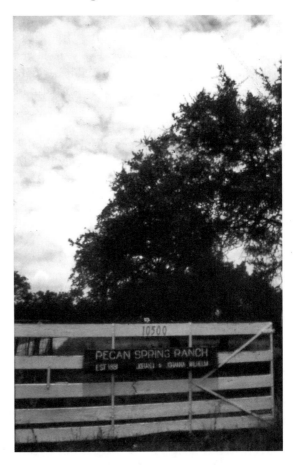

When her husband died, Johanna Wilhelm picked up the reins of the Pecan Springs Ranch, where they ran cattle and sheep, but she became famous along the East Coast for the quality of wool her sheep brought. People called her the "Sheep Queen."

When it came time to count and sell her sheep, Johanna wrapped her black cape about her and sat at the gate to Pecan Springs Ranch. As the sheep filed past, she counted them in German and tossed a rock. "She would toss a rock in a sack for every hundred sheep," recounted her great-great-granddaughter, the current resident and owner.

Weatherford Teacher Tamed the Panhandle

Molly Goodnight

Imagine a teenager arriving at a deserted Indian reservation in 1854 from a privileged life in Tennessee. That was Mary Ann Dyer, the only girl in the midst of eight brothers. Mary Ann or Molly's father lawyered, and her mother taught

the children. Eight years later, Mrs. Dyer died and Mary Ann stepped in to mother the three youngest boys. Two years later, her father also died.

To support her brothers, she taught, beginning in the Black Creek Springs School, between Weatherford and Fort Belknap. On the way there, in 1864, Mary Ann rode with her brothers, escorted by a patrol of Confederate soldiers for protection from Indian raids. She met Charles Goodnight on the way, and he fell for the attractive brunette with dark and flashing eyes and good humor.

Soon Mary Ann moved to teach in Weatherford. Between cattle drives, Charles called on her for six years and would "walk her to school" until he had a ranch of his own.

In 1870, they married in her uncle's Kentucky home. Arriving in Pueblo, Colorado, after a hanging, Mary confronted Charles about the execution and his casual disregard of it.

"I used to think I knew you in Texas," she snapped, "but you have been out here among the Yankees and ruffians until I don't know whether I know you or not, and I want you to take me back to Texas."

He agreed but talked her "into resting first" in Pueblo. That rest lasted three years, until the Panic of 1873 bankrupted Charles. Turning to Texas to start anew, he found the Palo Duro Canyon and an Irish backer while Molly visited in California.

Charles moved men and cattle to the canyon in 1876, prompting Molly to write, "If you will not leave the Panhandle and come out to civilization," she would come to him. In 1877, accompanied by John and Cornelia Adair, partners in the JA Ranch of the Palo Duro, Molly and Charles moved. Reaching the rim of the ten-mile-wide, nearly one-hundred-mile-long Palo Duro Canyon, she admired its red-walled, lush green canyon floor.

But it was 1,500 feet down. Wagons and supplies had to be dismantled and packed for the trip, a matter of eight days. They followed Indian and deer trails to the "velvety green sea" of buffalo grass and a cedar log house.

After Mrs. Adair left, Molly would not see another white woman for over a year, living seventy-five miles from any neighbor. Instead, she tended the cowboys—mostly young—taught them to read, doctored ailments with her bag of herbs and bandages, darned their socks, mended their britches and rode sidesaddle to line camps with fresh-baked cobblers and cakes. The hands called her "Aunt Molly." Settlers called her "Mother" or "Queen" of the Palo Duro.

When a hand brought her three chickens, she said, "No one can ever know how much pleasure and company they were to me. They were someone I could talk to."

In addition, Molly handled the business of the JA Ranch, analyzing contracts and keeping books. After a family arrived that freed her from household chores, she rode through the canyon on her sidesaddle designed by her husband, a safer

one. The ranch grew to 1.3 million acres and sixty-three thousand cattle. She established a herd of her own and another with a brother.

Dissolving the JA partnership when John Adair died, Molly and Charles moved to a smaller ranch in 1888. A town nearby called itself Goodnight after the family.

Along with the Goodnights came a buffalo herd of 250 that Molly preserved, although the noise of a buffalo stampede on her first night in the Palo Duro had frightened her. Indians and buffalo hunters had slaughtered buffalo until the animal neared extinction. Molly couldn't stand to hear the cry of orphaned calves. Charles brought her a couple that she nursed, then a bull, then more calves, and the Panhandle herd slowly returned.

At Goodnight, Texas, Molly proposed a college for young people from the small farms and ranches. The Goodnight College lasted from 1898 to 1917, when state schools eclipsed it. "Aunt Molly" mothered the students as she had her brothers and then the cowboys.

When Mary Ann (Molly) Dyer Goodnight died in 1926, at age eighty-seven, she had nurtured and taught the young and fostered schools and colleges.

"I never went to college at all or to any other school. There were no colleges in Texas nor public schools either when I was a girl," she said. "My only teachers were my father and mother, both of whom were well educated for their times."

"Then, too, I learned a lot from Nature," she reflected.

MINISTER'S WIDOW BLAZES TRAILS

Mary Jane Alexander

On the day of her wedding, Mary Jane Mathis dressed and waited. The prospective bridegroom did not show. Her family and friends fretted. Not Mary Jane. The man she had met as a college student in Missouri—an education interrupted by the Civil War—would come.

The Reverend C.W. Alexander took a steamboat from Missouri to Iowa. It had snagged a sandbar on the way, delaying his arrival. He and Mary Jane married a day late on September 22, 1868.

Not surprisingly, this daughter and granddaughter of Presbyterian ministers married a minister. It is said that when she was a child on "one Sunday morning of communion service day she went out into the timber after breakfast and remained a long time. She returned to her father saying that she had enjoyed a season of prayer, and had decided to unite with the church that day," which she did.

As a young bride, Mary Jane aided her husband in his work, first in Missouri and later in Texas. She "loved a good horse" and would toss her sidesaddle onto one to visit the sick. She taught school and with her first money earned bought a silver butter knife.

Children at the academy they operated, where she ran the dormitory, gained a friend. Known to have "burned up notes" of students whose parents could not pay, she embraced the needy ones. One girl hunkered in her room after Mary Jane discovered the orphan's abuse and took her in. In time, the safety of her new home and Mary Jane's caring eased the child into society, where she grew up to be a warm and respected woman.

Hewing to a dogma of no Sunday work beyond "necessity or mercy" paid off. On a Sunday, a man came to trade, his deal offering large profits. Mary Jane refused to do business on the Sabbath. Later, she learned the man was a fraud.

The Alexanders had moved to Texas in 1880, first to Ferris in Ellis County and then to Sherman. But a call to tame the wild took them to Mobeetie to establish its first church but with a rocky beginning. Arriving in the former buffalo hunters' town, the family caught typhoid but recovered. Not all welcomed them.

One man wouldn't rent them a house. He didn't think a minister in that town would have enough church members to pay. So, the Reverend Alexander approached saloon owners and other businessmen who financed the ministry he began in the schoolhouse.

He died two years later, though, in January, of pneumonia contracted in what the cowboys called the Great Die Up of 1886, a year of severe cold.

After his death, a minister called to offer assistance. Mary Jane needed to sign for the "usual grant of $150 from the Board of Pensions."

"We are not in want and we can make a good living for ourselves," she said.

While most would have taken the pension and retreated to a larger town, Mary Jane did not. She believed that hard work and faith would carry her.

In 1886 when blizzards riddled cattle herds, drought starved the grass and consumer demand pummeled beef prices, Mary Jane went into ranching.

In a time when the vast open range ranches were breaking up, the trail driving era was coming to a close and school lands were up for sale, she bought a section along the Washita River, near the town of Canadian. She moved her five surviving children there on November 10, 1886, becoming the first female rancher in the area. Next she started a Sunday school, becoming its superintendent.

During the sparse times, she and her children gathered berries and wild fruit, milked range cattle and sold dried buffalo bones for three dollars a ton until the ranch became self-sufficient. Yet any traveler, stranger or acquaintance could count on a meal at Mary Jane's table, along with a blessing. Scripture reading and prayers followed.

According to her diary, one "hardened" man who stopped told her, "That is the first blessing I have heard since leaving home and it makes me remember my own mother."

Over the next twenty years, Mary Jane rode the winds of the Panhandle's extremes—tornadoes, blizzards, drought and plenty—and grew her ranch from the initial 640 acres to over 5,000. Along the way, she educated her children through college. After twenty years on the Washita, Mary Jane left the Alexander Ranch and moved to town to live with a daughter. She died in Canadian in 1929, and her services were held in the Presbyterian church.

SOD HUT BRIDE TO FINANCIER

Dora Roberts

When red-haired cowboy Andrew Griffin rode into Brownwood to gather provisions for his new ranch, he swept tall, willowy Dora Nunn off her feet. They married and she packed her bags, and they left Brownwood to build a home and community on four sections of state school land farther west. She latched onto his dream of owning his own spread and left family and friends for an isolated patch of rocky ground. They honeymooned on the trip to his spread—a day's ride south of the "big spring," where a tent city had sprung up—in a wagon loaded with a year's supplies. Dora wouldn't see the tent city for months, and it was six months before she saw another woman, a neighbor—a far different life from Brownwood in 1881, with its trains, churches, schools, stores and doctors.

However, by year's end, the Denver Railroad whistled into Big Spring, linking residents to supplies. In the meantime, Dora and Andrew had carved a sod hut out of a rise of land on the 2,560-acre ranch he had purchased for fifty cents an acre, the price of a night's lodging.

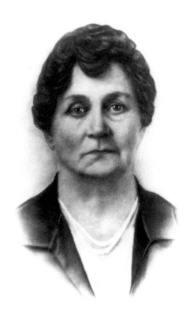

Dora Roberts followed her cowboy husband to this patch of land, near the Big Spring, close to the town of Big Spring today. A young bride, she survived blizzards and drought and the death of two husbands and became Big Spring's leading citizen and financier. *Photo courtesy of Heritage Museum of Big Spring Texas.*

At roundup, Dora chased cattle from the brush and gullies and branded, fed and tended calves. She straddled a horse and was said to be "as skilled with a loop as any hand." Come springtime, she prodded a small garden from the drought-prone soil, gathered eggs and churned milk into butter. Later, she would market these in the growing community of Big Spring while Andrew gathered buffalo bones to sell for fertilizer. They scrabbled but held onto land and cattle and built a one-room house, proving up their claim. At subsequent public land sales, they enlarged their holdings.

In the drought of 1887–88, Andrew trailed part of the herd north for grass. Dora and their two daughters stayed behind. She burned cactus to feed remaining livestock, and when a steer went down, she skinned it, trading two hides for a sack of flour.

Ten years and another drought later, Andrew was injured when his horse fell backward, dying a few days later from his injuries. At thirty-four, Dora became a widow and manager of land baked by sun and starved for water. She hired neighboring rancher John Roberts to help with the cattle and pastures— roundup, branding, moving beeves to graze. But it was her land and her cattle, and there was work to do. Plopping her daughters into a two-wheel buggy, she took off over pastures, checking cattle and fences, and toting a .22 rifle. The crack shot peppered jackrabbits to fill the cooking pot.

The year ended with a two-week blizzard. But Dora had hung onto the ranch and paid off the debts for her three hundred Herefords.

In 1900, Dora and John Roberts bought the land between their ranches and married, easing the struggle. They built a house in Big Spring in 1904 so her daughters could attend high school and lined the porch with rocking chairs for visiting. But if visitors called while Dora was hitched to a horse plowing the side-lot garden, they had to wait until she finished. By the time her girls graduated, another horse accident claimed John in 1909, so Dora had the ranch to run again and moved back to build her dream house.

A strand of ivy, painted green, decorated the eves. "I always want to see something green," said the survivor of droughts, blizzards, tornadoes and plunging beef prices. She directed that the house be built from rocks found on her thirty-two-thousand-acre Roberts Ranch where her grandchildren and great-grandchildren still gather.

In the late twenties, the area buzzed about oil, but Dora held out. She knew Herefords, and she loved the land, a lot more interested in water than oil. She grilled the promoters, however, and finally agreed in 1927, after negotiating the highest oil royalty in the region. The Dora Roberts No. 1 still pumps, among over nine hundred other wells on the Roberts Ranch, now renamed the Garrett Ranch after a grandson, and spews wealth for family and community.

Dora Roberts started housekeeping in a sod hut, surrounded by rocks, sand and cactus. Prospering with cattle and later with oil, she built her dream house from the rocks strewn across the land she loved and insisted on a string of green ivy beneath the eve so she would "always have something green to see." The Roberts Ranch continues today as the Garrett Ranch, named for a grandson.

Dora bought other ranches in the Permian Basin area. She also became a lending agent to help others finance their dreams. She gave to the poor. She funded hospitals, libraries and churches and always set a place at her table for visiting ministers. In a time when women were "seen and not heard," she presided over First National Bank in Big Spring. She expected people to listen. Yet she still donned her sunbonnet and sold eggs, butter and cream to the grocers on Saturday.

Before her death in 1953, at the age of ninety, she established and funded a large foundation. Today, Big Spring and Howard County remember her by placing Dora Roberts's name on projects as varied as recreation areas and gyms, charitable services, the library and the college, and the county converted her town home to a museum. Dora Roberts died in Fort Worth's All Saints Hospital, where she had lived and been treated for six months after a fall. Her gift to the hospital purchased the corner of land where the hospital sits today, much enlarged. In memory of her, the chapel bears her name.

Chapter 3

THE TOWN BUILDERS

1799–1925

W hether they hailed from Mexico, the United States or abroad, women sailed into or rode into a land of hospitable Indians, as well as combatants. They set foot on a shore that could disappear in high tides and hurricanes. They armed themselves and defended their families from the Indians who did not want them there. Often these women alone defended their young. But the land was rich and plentiful, the reward enticing. They did not wilt in the face of danger or savage weather. They grew communities on their ranches and beyond. First came education, then the church and then the culture of their respective heritages. One would eye history and the importance of preserving a tattered Texas icon. Yet all embraced the hospitality first begun by the Caddo Indian girl, Angelina, entrenched by subsequent generations.

REBEL RANCHER RUNS GUNS

Patricia de la Garza de Leon

One of the earliest women credited with bringing culture to Tejas—education and religion, especially—was a young Spanish royalist woman, Patricia de la Garza de Leon, who left behind the comfort and security of ranching near Cruillas, Mexico. Besides the culture she brought, she would become a Texas rebel and a gunrunner to the Republic of Texas Army troops.

This adventure began with her husband and two-year-old son and a line of carts loaded with supplies. Patrica de la Garza de Leon headed north in 1799. She crossed the Rio Grande into a land her husband, Martin de Leon, had

described, "where grass sprouted four to six feet high, buffalo, and antelope roamed and handsome wild mustangs galloped."

At her first home here—a *jacal,* a mud and grass hut—on the Nueces River, Patricia DeLeon swapped her fine silk and embroidered dresses for buckskins and a dream she shared with Martin of becoming empresarios. A woman who loved the outdoors and riding fine horses found herself and her growing family in a region rich in fish and vegetation, cattle, mules and mustangs, and in the midst of Indians who did not want them.

After ten years rounding up livestock and trailing them to New Orleans for supplies, hostilities with the Indians came to a head. Alone with her children, Patricia faced down an attack by firing a canon through the door of her home.

Relocating in 1810 to San Antonio for protection and trade and cultural advantages of the province's capitol, the De Leons continued ranching. She kept the books, reared the children and taught her daughters to become the finest seamstresses. She, and now her girls, again wore fine silks, embroidery on every petticoat. Denied their dream of becoming empresarios, despite her father's wealth and connections and DeLeon's military service, and for reasons they did not know or understand, Patricia and Martin stood by while the Spanish government awarded over forty such grants to Anglos like Stephen F. Austin and his father. The DeLeons switched loyalties, denouncing the Spanish and favoring the Mexican revolutionaries.

During the Mexican Revolution, they championed the rebels' cause, and when Mexico won its independence from Spain in 1821, the DeLeons won their colonizing grant. Patricia's inheritance financed what would be the only Mexican colony in Texas, the DeLeon Colony. She returned to the coast, riding in a gilded coach pulled by handsome descendants of the Andalusia horses. She placed her fine furniture on the dirt floor of another *jacal,* and she and Martin began building the colony, the town site, now Victoria, which she first named Victoria Guadalupe. They ranched nine miles out of town.

A first priority for Patricia was to build a church. She did, then furnished it and appointed it with gold and silver altar vessels that remain ensconced in St. Mary's Catholic Church, second-oldest Catholic parish in Texas, originally named *Nuestra Senora de Guadalupe.*

In the early years, she had her children home schooled. But now she hired a teacher for all children in the sprawling DeLeon Colony. While Martin governed and built the town, Patricia facilitated a strife-free community hosting dances, dinners and receptions in her home, the grandest in the region.

In addition, she minded their ranch on the Guadalupe River. Well schooled, and for years the meticulous manager of accounts, now Patricia rode roundup and oversaw stock raising while tending their eleven children

ranging from two years old to near adulthood. The colony was valued at $1 million, half of it theirs.

A cholera epidemic claimed Martin de Leon in 1833. Wearing black and grieving, Patricia managed both the ranch and the colony while rustlings of rebellion swept through Texas. Once again, Patricia, as head of her family, sided with the rebels, supporting Texas in its Declaration of Independence from Mexico. Her sons captained Texas Army forces. She bought guns and ammunition in New Orleans and smuggled them across her ranch to Texas troops.

In another time, Doña Patricia de la Garza DeLeon would have been honored. But in the backlash of war, those with Spanish names paid a price. Newer citizens changed the names of the church and the town she had founded to English names—St. Mary's for the church and Victoria for the town. Thieves ran off her livestock and robbed her homes. And then, one of her sons was shot and killed.

At age sixty, she led her family first to New Orleans and then, when safe, back to Mexico. But after seven years, yearning to go home, she returned to Victoria in 1844. She spent her remaining years petitioning the republic and then the State of Texas for war reparations. She tried to collect debts owed her by neighbors in the colony. None paid. She willed these debts to her children in equal amounts and spent her time worshiping in her beloved church, now St. Mary's. When she died in 1849, she donated her home to the parish.

DEFIANT TO OLD WAYS, SHE FORGES A TOWN

Margaret Hallett

What caused her parents grief may well have steeled Margaret Leatherbury for a life in the West. Born in Virginia in 1787, the youngest in a prosperous family, she cast her love and her lot with a Royal Navy man who had jumped ship and joined the Americans. Margaret met John Hallett in 1805. Her parents opposed the marriage to a merchant seaman.

"I would rather marry John Hallett and be the beginning of a new family than remain single and be the tail-end of an old one," she said and married him in 1808. After the war of 1812, land opened west of the Mississippi. Margaret and John joined a wagon train, settling first in Matamoros, Mexico, where they operated a mercantile business and welcomed the birth of two children.

By 1818, Margaret, John and two children moved into Tejas, to Goliad, birthplace of their next two children. They lived in town, yet in 1833 settled a league of land as part of the Austin Colony on the Lavaca River and built a cabin. But in the year of Texas' independence in 1836, Margaret's life changed.

John died. Her two older sons served in the war and survived, but then one fell to Indian attack and the other was killed on a land-buying trip to Matamoros. The youngest boy had died earlier.

Margaret and her only daughter survived. When word reached her that people were settling on the Hallett League, 4,428 acres along the Lavaca River, she, at forty-nine, and Mary Jane, fourteen, saddled up and rode to their cabin. There she met not only the new settlers but also a pair of Tonkawa Indians who would figure in her life the rest of her years.

Margaret arrived in the midst of terror. Comanches raided on her league. The men did not want to leave their families to hunt for food. Margaret took charge. She called a meeting of settlers and Tonkawas. The Indians would accompany the white men to Bexar (later San Antonio) to summon the Texas Rangers. Margaret stocked the riders with prepared meat and cornmeal cakes and laid out the safest routes. Two weeks later, the Rangers had cleared the Hallett league of the Comanches.

Now that her league and its growing settlement were secure, Margaret's next town-building task was to provision the community. She stocked her cabin and conducted a thriving trading post on the banks of the Lavaca, bartering "coffee, sugar and other necessities for hides, pelts, and corn which the settlers and the Indians brought in," according to *Women in Early Texas*. The Tonkawas would warn Margaret of approaching Comanche raids, giving her and the other settlers time to hide.

As time passed she, too, planted corn and stocked her acreage with cattle and a few good horses. One day, a couple of Indians entered her trading post and demanded whiskey. She refused them. When one reached to help himself, Margaret "picked up a hatchet and hit the intruder on the head." Tonkawa Chief Lolo was so impressed with her bravery that he "made her an honorary member of his tribe."

On the political front, the Congress of the Republic of Texas created Lavaca County, and Margaret's cabin housed county and district court sessions. Her cabin turned trading post hosted community gatherings and church meetings. She donated land adjacent to her cabin for the town site. The settlement of German and Czechoslovakian immigrants that grew up on the Hallett league came to be called Hallettsville in Margaret's honor.

In 1852, a fight brewed between her township and a neighboring town in the county over which would be the county seat. An election favored Margaret's town but the other, Petersburg, would not give up. To settle the matter, she ordered the records loaded onto an ox cart and brought to her cabin. Hallettsville has remained the county seat.

While her daughter had attended a nearby convent for schooling, the need for a community school grew. Margaret donated land and helped organize the Alma Male and Female Institute in 1852, the first public school in Hallettsville.

When town founder Margaret Leatherwood Hallett died in 1863 at seventy-six, she had been a widow for thirty-seven years, one who defied tradition by wearing bright colors instead of mourning black. Townspeople and the Tonkawas, friends throughout her time on the Lavaca, buried her near her trading post. With John, fifty-five years earlier, she had started not only a new family but also figured in the development of a new country, state, county, town and school.

TAKING CHARGE

Mary Wightman

From marrying her schoolgirl crush, her teacher, to sailing for Texas, Mary Sherwood Wightman embarked on a frontier adventure. She has been called the co-founder of Matagorda, a town site her husband surveyed. Yet more than co-found the town, she embraced the life Texas offered upon her arrival from New Orleans on January 27, 1829, after weeks, not days, at sea.

Perky and young and a teacher from New York, fellow voyagers on the schooner *Little Zoe* voted that she should be the first down the gangplank to the Port of Matagorda, to be the first woman. The weeks when weather arced between becalming the ship or driving it past Matagorda on hurricane winds had not wilted Mary's excitement.

She described her new land as rich in deer—where hunters could go out and "surround" a herd to catch or kill the game, where fish and oysters were abundant and where "waterfowl eggs lay in clumps on the beach."

Nor did the fact that the town site's nearest neighbors were the Karankawa Indians dim her spunk, even though they were said to be cannibals. Mary slept with cabin doors open and twenty-five to thirty Indians just yards away. While she frowned on their way of life, Mary mourned when a colonist shot a Karankawan in the afternoon, a man she had fed in the morning.

Mary joined her husband trekking throughout the Austin Colony, at Empresario Stephen F. Austin's request, to survey land grants and town sites.

She and Elias built a rudimentary home in Matagorda and later a summer home at Caney Creek. Mary set a hospitable table, welcoming, as the custom went, all strangers with a meal at no price. Her hospitality would stand her in good stead.

Shortly, impromptu cannon fire punctuated the calm while Texans and Mexicans skirmished in the run up to the Declaration of Independence and the Revolutionary War. The autumn before, Mary and her husband traveled home

to New York for a visit; they returned on a vessel loaded with volunteers for the Texian Army. The female passengers made cannon cartridges.

After the Alamo fell, and with the province caught up in a void of communication from the military to the civilians, Mary led a band of women back to sea to escape the feared Mexican Army. They buried household goods and food stocks and ran in what's been dubbed the Runaway Scrape. They packed essentials into a one-horse cart and arrived at abandoned Velasco (present-day Freeport) near noon. A pleasure vessel steaming for the Sabine let them board but refused to let them bring provisions. Mary sent her cook below decks to prepare their food for she insisted on having soup for the sick under her care. She rounded up scrap sailcloth to make sleeping partitions.

Responsible for the band of seventeen fleeing women, children and infirm that included her sister—and not cowed by the vessel's rules and regulations— she "ordered" a good dinner for her charges. She could pay. Mary carried $2,000 cash sewn into her corset for safekeeping. When they reached Sabine Bay near the present town of Beaumont, a ship arrived with provisions, sent by Mary's husband.

During this time, the Texans had won the Battle of San Jacinto and the journey back to Matagorda began. It started with a rough craft sail from the upper bay toward Galveston, then Mary prevailed on a cart man, a fellow with a cart for hire, to take them, then a flatboat operator to ferry them to the island. They walked, rode and pitched in wallowing shallow watercraft and walked some more.

When Mary met the commandant of the island, he remembered her hospitality and would take no fee. He ordered tents and rations for her and her party, and they joined in the spoilage of war with her favorite, peaches in sugar and brandy.

Detained because of rumors and fear of further invasions, Mary wheedled. Her tears worked, she said, and her group boarded a Texas Navy warship to go home to Matagorda. That trip, too, was cut short. When beached, she pressed a Texas Army officer for the use of his horse for the final thirty-five miles. It was July. She had been gone since March.

But she returned to her life with Elias and continued as settlement leader, teacher and music teacher until they left for New York in 1841 in hopes of improving his health. He died soon after, and she remarried.

Fifty years after her first footfall on Texas soil in 1878, Mary Wightman Helm returned to Texas and wrote some of her remembrances in "Story of an Old Pioneer" for the *Clarendon News*, a West Texas newspaper.

TEXANS BOUND BY STRONG TIES

Frances Van Zandt

"We were all strangers together, willing to lend or borrow as the case might be," wrote Frances Lipscomb Van Zandt, an early settler in East Texas. She, her husband, Isaac, and two children crossed the Sabine River into Texas and stopped at Camp Sabine in 1839. "There was good water and the empty houses made it a convenient and much used stopping place," she wrote. This "camp" of fifty log houses had been the capital of the Spanish province from 1721 to 1773, Angelina's time in the early years.

The Van Zandts waited a few months, hoping to collect some debts owed from a former partner in Tennessee. Instead, Frances's husband caught a "malarial disease." To save him, she swapped "one of my two best dresses for a bottle of medicine." Her other dress bought them five bushels of corn.

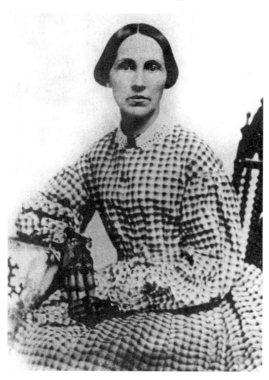

Frances Van Zandt, a pioneer Texan, sent her husband off to lobby for Texas' admittance to the United States, although she favored the Republic. *Photo courtesy of the Van Zandt family.*

When Isaac recovered, they settled in Harrison County in a one-room log cabin with "chinks between the logs such that wind sailed through and blew the covers off the bed." Neighbors lived close by—two families each a mile away. They socialized and took care of each other.

"We had just one enemy, Mexico," the young bride said. "We were all Texans ready to shed our blood for our independence and bound together by stronger ties than we had ever known in our old homes."

When Isaac—elected to represent the republic in Washington in 1841—was away, "I found the neighbors always ready to do anything they could for me." A neighbor man would "take

our gun and kill a deer for he knew we needed meat." She spoke of the scarcity of meat and recalled, "I think the best piece of bacon I ever ate was a piece for which I bartered a chicken from a young woman camping nearby." Convinced by a hunter's wife of the delicacy of bear meat, "white and tender, like good pork…I was anxious for some…at last a bear was killed and I was not forgotten in the distribution."

Continuing her story of Texas' neighborliness, she told of her first wedding invitation in Texas. "I carried the dress in which the bride was married, and the plates for the wedding dinner."

She spun and wove her family's clothes, proud to send her husband off to Congress "with a pair of socks and an overcoat from a blue blanket" she had made.

In his role, Isaac Van Zandt worked to accomplish annexation of Texas by the United States. Yet a few Texans valued the independence of their own country. "I must confess," Mrs. Van Zandt said, "that I had a little of this feeling myself."

The Van Zandt family lived in Washington, D.C., while he represented Texas in its quest for statehood. Returning home to Texas, they settled outside of Marshall, Texas, on a plot of land with "a smoke house and one good room, which was to be the kitchen, where we lived while our house was being built." Townsmen urged Isaac to run for Congress. But Frances balked, not wanting to return to Washington nor have him gone so long. She did agree for him to seek the governorship of the new state.

But not long after he launched his campaign, she called him home for the funeral of their youngest, their first child born in the state of Texas. Six months later, Isaac died too, in the yellow fever epidemic that swept Houston, the capitol, in October 1847.

At thirty-one, a widow with five children, she supported her family by swapping corn for cloth, pinching pennies, sewing, leaning on neighbors and helping them as she could until her children could help. Marshall became home, and she sent her five remaining children to Marshall University, a private school (not a college), before her sons rode off to war with the Confederacy.

Frances Van Zandt presided over the Soldiers Aid Society of Marshall, knitting socks for the Confederate troops. Of the hard times that resulted from a losing war, she said: "Those of us who had been long in Texas had had training in hardships and poverty that stood us in good stead in this later trouble."

Afterward, she joined her veteran sons when they headed to Fort Worth. Until her last breath in 1909, the Virginia-born, Tennessee-reared woman savored the Texas heritage she helped create. In her later years in Fort Worth, she sought to let younger generations—including her 104 descendants, as well as newer residents—treasure Texas' friendliness.

Van Zandt Cottage. Frances Van Zandt moved with her sons to Fort Worth following the Civil War, and she wrote her memories of her life in Texas for her long and extended family. Her descendants continue to contribute to Fort Worth's culture and economy.

"Texas was to me the land of promise; the land of our adoption, and the trials of those first years—which then did not seem very great—but made me love it the more!"

"THE HEALER" BUILT LIVES, A RANCH AND A TOWN

Henrietta King

In 1852, a teenage girl went out to scrub the deck of her father's boat, the *Whiteville*, home for the new Presbyterian minister's family in Brownsville. That morning, another steamboat chugged up and the captain barked, "Cast off that line and let loose that stinking rat trap."

Henrietta Chamberlain yelled, "And you sir are not a welcome visitor either. The *Whiteville* is a great sight...cleaner than the *Colonel Cross*." Laden with molasses barrels, the captain's boat deck swarmed with flies.

Most men would have backed down from Captain Richard King, but when Henrietta did not, he steamed on down the crowded Rio Grande River Port pier.

Her father's life instructions, that she could "master her own destiny…that a girl didn't have to be a clinging vine," guided Henrietta then and later. His letters also had admonished her to stay in boarding school, even though she chafed under the school's lessons of the social graces and the arts of feminine wiles.

Instead, she sought the library and its treasures of the classics, poetry, world politics, history and philosophy. She wanted to teach. Once in Brownsville, she learned Spanish so that she could. When her students' needs exceeded the classroom, she pitched in to help them, and she believed every girl should be educated.

The steamboat captain soon came to church to meet Henrietta. Over paternal protests, she danced with Captain King, and then she married the steamboater in December 1854. He called her Etta, and she called him Captain.

They left for the Santa Gertrudis, some ranch land he had purchased, in a coach with armed guards. A three-room *jacal* awaited Henrietta.

"I'll build you a mansion," King is reported to have said.

"I don't need a mansion, Captain, just a larger pantry," she said.

When she eyed a pair of saddled horses that he rode up with, he said, "Don't you ride?"

"I ride but always sidesaddle. Don't worry, I'll manage."

She did, despite her full calico skirt, muslin petticoat and ruffles. At the day's end of her first survey of the range she would one day run and expand, Henrietta improved on the riding habit by sewing a divided corduroy skirt.

They brought different values to the partnership. Henrietta brought the scriptures; King, the whiskey, but out of her sight. She read the Bible on Sundays; he did not but respected her practice.

One of her routines was to call upon the ranch families of the Santa Gertrudis, later called King Ranch, in the Wild Horse Desert. Henrietta brought medicine and once saved a newborn's life. People called her "the healer" and sought her help in times of illness and accident.

Stepped-up violence in the isolated desert sent Henrietta and children back to Brownsville, but by the time their third child was born, she announced, "Our home is the ranch…our children must grow up to love the land, to know it as we do."

After the Civil War, from the porch of her "big house," a long way from the *jacal*, she watched their longhorns stream out of sight on the cattle trail.

Then ranching changed again. Barbed wire ended the trail drives in 1884, and the next year, Henrietta's captain died. His will left "everything to Etta." Everything included a half million acres well stocked with cattle, hogs, sheep and horses, and hundreds of thousands of dollars in debt.

Despite her grief, the change of cattle marketing, droughts known as the Great Die Up and border wars over the next decades, Henrietta oversaw tremendous

growth. She had brought in their attorney in 1885 to manage the business, and the next year, Robert J. Kleberg married her daughter.

For years, Henrietta and Kleberg worked together, swapping land, buying more, paying off the debt and developing the Santa Gertrudis breed, while doubling the ranch to a million acres.

In 1904, she donated land for the City of Kingsville. For years, she gave land to denominations wanting to build churches.

While Henrietta had employed teachers at the ranch since the early days, in 1909 she designed and gave a building "stout enough to withstand hurricanes" for a school. The preacher's daughter implored the school board "to employ great care in selection of the character builders for the work within." She added, "Civilization has finally arrived on the Wild Horse Desert."

For forty years a widow, Henrietta, known as "La Patrona," wore black dresses and a brooch of her captain and twice a year rode out to oversee roundups.

At her death in 1925 at ninety-two, two hundred mounted King Ranch *kineños*—King's men, cowboys brought by Captain King to the Santa Gertrudis from Cruillas, Mexico, Patricia Deleon's birthplace—rode, circling her grave to pay respects to "La Patrona." In later years, a grandson wrote, "in this family, it's the women who make the difference."

Chapter 4

HEROINES ON THE FRINGES

The toughness, rebelliousness and deeds of a number of women have been celebrated in myth, song and legend. Some arrived in Texas with sullied reputations, and their actions brought them respect, if not fame. Others arrived or grew up here and circumstances arose that fueled heroic deeds. And they responded.

REBS DUB SOPHIA THE "CONFEDERATE PAUL REVERE"

Sophia Porter

A teenage bride strode into Texas on the eve of revolution. Fleeing a sullied reputation on an Indiana army post, Sophia Suttonfield had married the post's schoolteacher, Jesse Aughinbaugh, and convinced him to take advantage of the free land being advertised in Texas.

They settled along the Trinity River, north of Liberty. But soon, Aughinbaugh was gone and Sophia flirted in the saloons of Washington, later known as Washington-on-the-Brazos. She danced with the leaders who declared Texas' independence.

Sophia followed the Texas Army to San Jacinto. She boasted, "I was the first one to him," referring to the wounded general, Sam Houston. She did do some practical nursing and developed a friendship with Houston in the bustling town that bore his name. He helped her get established to operate a hotel for troops.

While president, Houston drove through an act of Congress to legally sanction Sophia's divorce from Aughinbaugh so that she could marry his friend and fellow officeholder Holland Coffee. She and Holland settled at

The Brazos River, at what is now called Washington-on-the-Brazos, ran over its banks while the Texians were planning a revolution and signing the Declaration of Independence. Sophia Aughinbaugh had "lost" her husband and arrived here, enjoying the revelry of the revolution, before following the army south to San Jacinto.

Preston Bend on the Red River, arriving in 1839. She described her new home, "a lap board house with puncheon floor...our table consisted of a dry goods box with legs." A rag rug that she made warmed the floor, and another dry goods box held her clothes. "I was the happiest woman in Texas," she said.

Coffee's Trading Station thrived. Sophia ran the cattle and cotton operations on their league of land. They built a two-story dogtrot and called it Glen Eden.

Military travelers like General Albert Sidney Johnston, Robert E. Lee and Ulysses S. Grant and adventurer Randolph Marcy stopped there. They dined with Sophia and Holland, if he was not away on trading and hostage rescue trips. She included the handsome young officers from the military wagon trains at her balls and dinners, developing quite a reputation.

Tired of the rumors that had surrounded her for seven years, anytime Houston visited or she held a dance, Sophia challenged Holland, saying, "I'd rather be a widow of a brave man than the wife of a coward."

He called out the latest tale spinner, his nephew, and lost the duel in 1846.

At Holland's death, left with five thousand acres, nineteen slaves and herds of cattle and horses, plus the trading post and a large debt, Sophia soon married downstream trader and ferry operator George Butt.

They continued entertaining, bringing the latest fashions, fine china, furniture and wine to Glen Eden, now Glen Eden Plantation, from their cotton and cattle selling trips to New Orleans.

Butt ran the trading post; Sophia minded the crops, cattle and slaves and pursued interests in horticulture. She grew the first roses in Grayson County; a magnolia tree that started as a sapling, a gift from Houston; and Catalpa trees from seeds that General Johnston sent her from California. Grapevines snaked around the house.

When secession fever seeped into Texas, Sophia and George supported it.

The outlaw band Quantrill's Raiders hid out in the Red River breaks. Sophia and Butts criticized them and became targets. On Christmas Eve 1863, at a ball at the Ben Christian Hotel in Sherman, Sophia danced. Two of Quantrill's men, drunk, spurred their horses inside. One spotted her.

She ignored them and kept on dancing. The raider bet his partner he could shoot the tassels off her hat. And he did. Sophia kept on dancing. Partygoers vouched that she never stopped dancing.

A couple of weeks later, George Butt rode into Sherman to sell cotton. He didn't return. A week later, his body was found.

Widowed again, Sophia continued to operate Glen Eden. At times, she and her slaves stacked cotton bales two stories high to ward off Indian bullets and arrows and the new danger from patrolling federal troops.

One cold, January day, warned of approaching Union soldiers, Sophia swung into action. She invited the soldiers in for "home cooking," then a tour of her wine cellar. When they were drunk, she slipped

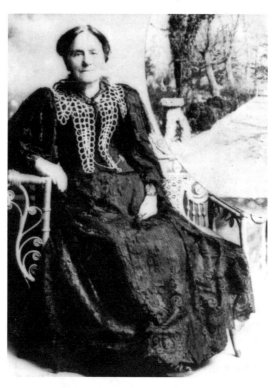

Sophia Aughinbaugh Coffee Butts Porter arrived in Texas as a frisky teenager, eventually settling along the Red River of Texas' northern border. She was later revered as "the Confederate Paul Revere." *Credit: Red River Historical Museum of Sherman.*

out, locked them in, grabbed a mule and swam the river to fetch a Confederate patrol. After picking up the corralled Union soldiers, the Rebels dubbed Sophia the "Confederate Paul Revere."

She was too visible now, and it was time to leave for Waco, the nearest refugee center. There she met and married her last and perhaps best-loved husband, James Porter. After the Civil War, Sophia recovered her wealth and, with Porter's influence, settled down, still entertaining Texas politicians but closing the wine cellar and stopping the dances.

When she died in 1897 at eighty-one, her funeral at Glen Eden drew hundreds of visitors from afar to mourn, the "Confederate Paul Revere." Sophia Suttonfield Aughenbaugh Coffee Butts Porter had reigned along the Red River for fifty-eight Years.

MYTH AND SONG FOLLOWED HER

Emily D. West

Emily D. West's beginnings—her family and her ties to New England or, for that matter, any debt, argument, abandonment or disgrace she may have fled—remains hidden in the archives of her life. Whatever her roots or cause, she signed up for a voyage to the "foreign land of Texas," as the words on her bond called Texas, in 1835.

Leaving the port of New York on the schooner *Flash*, the light-skinned free black woman agreed to work for one year for an early Texas wheeler-dealer, joining a shipload of tradesmen and women. For her services, Henry Morgan would pay her $100 at the end of her one-year stay, plus return passage.

Cold and wet upon her arrival, and with her boss off to raise money for the new revolution, Emily, who could read, write and cipher, ran his new hotel. Soon after the new year of 1836, the hotel would be overrun in Texans' Runaway Scrape. Texans declared independence from Mexico March 2, 1836. The Republic of Mexico objected.

Settlers fled the advancing Mexican army. Mexico's president and general, Santa Anna, pledged "to kill all Anglos." Emily clerked at Morgan's hotel on the banks of the Sabine River, where those fleeing bunched up on the swollen, alligator-riddled riverbanks. Across the Sabine on the Louisiana side, the United States flag offered protection.

The elderly, women and children queued up to board the ferry. Meanwhile, Emily helped another Emily (Emily DeZavala) and her children board a one-masted skiff and sail away.

General Santa Anna's army captured Emily D. West, the hotel clerk. On his romp through Texas, he had collected chocolates, liquors and fine china. He traveled with a stagecoach full of women for his pleasure. Now he had Emily. The next stop, the Plains of St. Hyacinth (or San Jacinto) would be where Emily's fame flared. Santa Anna ordered his troops to rest. He undressed and retired to his chocolate brown and white silk tent, purportedly for a rest or a tryst.

Taking advantage, the Texians overpowered the larger Mexican army. In eighteen minutes, the Texians won. And there the legend that threads through Texas history begins. War stories fanned by Morgan and Sam Houston declared that Emily distracted the Mexican general, which allowed Texas troops to surprise and overrun the Mexican army. That's the tale, or one of them, that has followed Emily since that battle. Historians say this is not so.

Emily's plight worsened. Whether she entertained Santa Anna or whether she even knew of the story that gave her heroine status is not known. But she panicked, searching the battlefield and demanding help. Somewhere in the mud of the tented encampment, strewn beneath an army of Mexican bodies and trampled hyacinths, lay Emily's papers. Lost.

Those papers—her bond, her emigration status—proved that she was a free black, not an escaped slave. Those papers proved her right to return to New York, expenses paid. Her boss, now Colonel Morgan, dispatched a junior officer to vouch for Emily, and she returned to his plantation to sew, keep house and launder until a new hotel could be built when Morgan returned from Texas Army service.

Here she served out the remainder of her agreement: to work for one year in exchange for salary and return passage. And it was here that her beauty—she was called "tall, lithe, attractive, with long black hair, looking Spanish"—gave birth to a new story.

A courier brought a letter written and sealed on light blue stationery to Sam Houston, now the president of the new and independent Republic of Texas. Emily readied to leave, going home on the same schooner she arrived, and once again helping Emily de Zavala depart with her children on the same ship.

Penned in tidy script, still clear today, were these words:

There's a yellow rose in Texas
That I am going to see
No other darky knows her
No one only me
She cried so when I left her
It like to broke my heart
And if I ever more find her

A courier brought the words, written on powder blue linen-textured paper, to Sam Houston, president of the Republic. The words are the original lyrics to the popular "Yellow Rose of Texas," presumably written to honor Emily D. West, a free mulatto woman working on the Morgan Plantation who had been captured by General Santa Anna. *Moss (A. Henry) Papers, 1820–1897, No. 05673, The Dolph Briscoe Center for American History.*

We nevermore will part.
She's the sweetest rose of color
This darky ever knew
Her eyes are bright as diamonds
They sparkle like the dew
You may talk about dearest May
And sing of Rosa Lee
But the yellow rose of Texas
Beats the belles of Tennessee.

The love song was first hummed and sung around the slave shanties on Morgan's plantation. Many believe that a slave sang it about Emily, while someone else copied the lyrics and sent it to Sam Houston. The words have changed until it's the song we know today as "The Yellow Rose of Texas."

Emily D. West left Texas in October 1837, homeward bound for New York.

Shunned but Valiant

Elizabeth Ann Carter

Elizabeth Ann Carter seemed to care little what other people thought. Or perhaps what other people thought drove her to independence as a teenager and to hardheaded heroism as an adult. Born about 1826 in Alabama, people believed her to be possessed by demons or hopelessly insane, when in reality, she had epilepsy. Yet she would become a leader, putting the welfare of others first.

In 1842, she arrived in Red River County, Texas, alone and illiterate. Within months, she married Alexander Carter, a free black, and she farmed and bore two children. By 1857, the tall grass of Young County, ripe for foraging cattle, beckoned the Carters to move west from Corsicana. The army established Fort Belknap to protect the frontier, and Elizabeth's family settled about two miles north of the fort, near the crossing of the California gold rush trail and the Butterfield Mail Route. While the Carter men hauled corn for the army, Elizabeth ranched, having negotiated a fifty–fifty partnership with her father-in-law. Their station changed out horses for mules for westbound wagons because the Comanches wouldn't steal the mules. Eastbound, they switched mules for horses for the traveling wagons and stagecoaches.

She raised horses, mules for the station and cattle, and matured into a smart businesswoman, ignoring taunts of "nigger lover" and "demon," while concentrating on her ranch, rounding up cattle and sending them to market in Louisiana.

In a time when few people had "money at interest," Elizabeth's father-in-law banked $1,360 that year, a thousand more than anyone else. Another settler, known to be jealous and prejudiced, ambushed both father and son, killing them. The killer went free.

Not only vulnerable as a widow, Elizabeth lost the protection her black family had provided because Indians didn't attack blacks. Now, she was another white rancher with cattle and horses to steal. She operated alone for four months before marrying a soldier who bragged about marrying "the richest woman in the county." But Lieutenant Owen Sprague didn't last long before he disappeared, probably just wandered off. She continued ranching and operating the station.

Fort Belknap closed, causing many settlers to retreat to Parker County, a more populated area. By Christmas 1860, the fort was deserted. But Elizabeth remained and continued to celebrate Christmas as usual by inviting friends to do-si-do all night, eat candy apples and drink potent "black tea," a hard liquor concoction.

Soon after, she hired a cowhand for protection and then married him in 1862. Eighteen months later, he was murdered. In October 1864, seven

Much of the land west of Fort Worth and Weatherford was rolling hills, scrub cedars and lots of rocks. A house and stable built in the 1850s here typifies life on these prairies. Not far away, Elizabeth A. Carter moved and set up a way station on the "Gold Road" to California.

hundred Comanches and Kiowas swarmed her ranch in the Elm Creek Raid. In the last battle, Kiowas killed Elizabeth's daughter and captured her and her two granddaughters.

A slave, beaten, burned and scarred, she lived on what the Indians gave her to eat, "raw liver, boiled greasy buffalo meat, and charcoal roasted tortoise and dog meat," until November 1865, when the U.S. Army rode into a Kiowa camp in Kansas.

Elizabeth spotted them. "They must be beings from another world...their white faces and blue uniforms looked so beautiful," were the thoughts she later described to a neighbor. The army brought her in to Kaw's Mission at Council Grove, Kansas.

She cooked, nursed and sewed clothes for weaker captives and learned that one granddaughter had been returned to friends in Texas. The other was still "out there," she believed, although Indians reported that the toddler had died

Prairie forts came and went. Names were interchangeable. Most of the soldiers left for other postings during the Civil War, leaving women, children and the elderly in tight spots when the Comanches raided. Elizabeth Ann Carter, a captive of one of these raids, bucked officialdom when rescued, insisting that she and other captives be returned to Texas. Some, like Fort Richardson here, were rebuilt and fortified after the Civil War.

in the bitter winter. Elizabeth badgered the army. She told about others in the camps where she had been. "They shiver in the wind," she said.

"If all the captives still unaccounted for belonged to those whom the business of rescuing them was committed, they would have been rescued months ago," she said. Her persistence paid off. A colonel asked her to ride with him, and she directed him to an Indian settlement where she had seen another captive's daughter. They returned with the girl.

Continuing to press for her grandchild, Elizabeth also pestered the army to return the Texans home. Fed up with the army's foot-dragging, Elizabeth told a man from Texas that she would pay the expenses for all of the Texas captives if he would take them home. She had socked away the $3.50 a week the mission paid her for helping with the rescued women and children.

That spurred the army into putting together a string of four wagons with food and spare horses.

Elizabeth drove one wagon and tended to all the children. Not until the last of the thirteen Texas captives had been reunited with family or friends in the Wise County seat of Decatur, on outlying farms and ranches in the county and in Austin did she leave the wagon train at Gatesville to rest and regain her health before joining her granddaughter in Parker County. After her captivity, she never had another seizure, nor did she ever return to Carter Ranch; she ordered the assets sold.

A couple of moves later, she married Isiah (*sic*) Clifton in 1869, at his place near Fort Griffin, beginning a comfortable marriage and a quiet decade. She died June 18, 1882, and is buried next to him in an unmarked grave near old Fort Griffin, a quiet but hardheaded heroine of the Indian wars.

A Gunslinger, a Muleskinner, a Mystery

Sarah Jane Newman Scull

Stories have skittered around Sarah Jane (Sally) Newman Scull like buckshot. Stories about her sharp shooting; her cussin'; her aid to the Confederacy; her love of children, hers and others; and stories about her five husbands—she killed one, the last killed her—so they say. Separating fact from fancy about a woman men feared and women jeered can be tricky.

Born in 1817, Sally toddled into Texas in Austin's Colony with her large family to a spot called Egypt on the Colorado River, near present-day Wharton. In 1831, her father died and Sally married at fourteen, perhaps attracted to a man who helped save her family from Indian attack. That husband, Jesse Robinson, fathered her son and daughter.

Two years later, Sally registered her brand at Gonzales. In Mexican Tejas, women owned property and controlled their own inheritance until the Texas Revolution brought in English laws. Her brand was "the letters, J N," the "J Fly Loose," an idea that seemed to characterize her. The brand reflected her maiden name, according to tradition.

Then her husband fought at the Battle of San Jacinto, and Sally fled with their children in the Runaway Scrape.

In 1843, she divorced Robinson, although he charged her as "a great scold" and accused her of adultery. She claimed he wasted her inheritance and that he beat her.

Eleven days later, she married George Scull, a gunsmith, and carried his name throughout her life. The next year, they sold the last four hundred acres of Sally's inherited land. It is believed that she placed her children in a convent

in New Orleans for care and education but visited often. In 1849, Sally returned to Wharton and announced that Scull was dead.

But he was not.

She moved to DeWitt County in 1850, near her sister, but in 1852 set up her horse-trading and freighting operations at Banquette, a water stop between the Colorado River and the Rio Grande.

A European tourist wrote: "a perfect female desperado…She can handle a revolver and a bowie knife like the most reckless and skillful man; she appears at dances (Fandangos) thus armed, and has even shot several men at merry-makings…She drives wild horses from the prairie to market, and takes her oxen-wagon, alone, through the ill-reputed country between Corpus Christi and the Rio Grande."

Tax rolls in the early 1850s suggest Sally was not successful, but horse traders and cattlemen then were "not noted for their accuracy in rendering all their livestock to the tax collector," according to Dan Kilgore, author of "Two Six Shooters and a Sunbonnet," in *Legendary Ladies of Texas.*

While retaining Scull's name, she married her third husband, John Doyle, in 1852. Legend says she killed him. Then in 1855, Sally bought 150 acres on Banquette Creek and claims to have married her fourth husband but "abandoned him" five months later, accusing him of beating her and of adultery. The jury agreed.

On the eve of the Civil War, Sally married her last husband, who was eighteen years her junior.

While he, as it was said, "just stood around," Sally prospered smuggling cotton from Texas plantations to Matamoras, Mexico, for shipment to Europe for the Confederacy. The Union's blockade of Southern ports had dried up Confederate trade revenue, but the United States could not blockade a foreign port.

Sally took up hauling cotton and strung together a mule train that tramped the meandering route of the "Cotton Road," the old El Camino Real.

One man described her: "Superbly mounted, wearing a black dress and sunbonnet, sitting as erect as a cavalry officer, with a six shooter hanging at her belt, complexion once fair but now swarthy from exposure to the sun and weather, with steel-blue eyes that seemed to penetrate the innermost recesses of the soul."

On the trail, Sally rode astride her Spanish pony Redbuck in men's clothes, or as one called it, "rawhide bloomers." She bossed her men, Mexican vaqueros, her mules and anyone who got in her way.

Sally's son rode with the Confederacy and, when the South was losing, wrote his wife: "Mother promised me that she would assist you to get away…I saw mother at King's Ranch but had not time to speak to her but a few minutes."

In 1868, he and his deceased sister's sons filed for Sally's land on the belief that she had died. Legend says her last husband killed her. But no one knows.

Two miles north of Refugio today a historical marker reads "Sally Scull… woman rancher, horse trader, champion 'Cusser'…Loved dancing. Yet during the war, did extremely hazardous 'man's work.'"

MODEL FOR *GUNSMOKE*'S MISS KITTY

Lottie Deno

Carlotta Thompkins, or Charlotte Tompkins, better known in Texas as Lottie Deno, grew up in privilege and culture in Kentucky from her birth in 1844 until 1862. In later years, she returned to the culture of her upbringing in New Mexico as Carlotta Thurmond.

But for a dozen years in Texas, she lived a different life, one that has continued to spin the threads of imagination in West Texas about this tall, red-haired woman who could deal a mean pack of cards.

As a youngster, Lottie, a daddy's girl, accompanied her father to the finest gambling casinos in Europe. She watched the horses from their plantation run at races in the States. Like many, the Civil War upended Lottie's life. Her father was killed. Her mother and sister managed the plantation and sent Lottie to Detroit in 1862 at eighteen to find a husband of the "right social standing" to help them all live in style.

Instead, Lottie found a jockey who had ridden for her father. But what drove her mother to disown Lottie was that the jockey was Jewish, an affront to her mother's Christian beliefs.

Lottie joined this jockey in gambling. Her European-trained skills paid off. Now disowned, she went with him to gamble along the Ohio and Mississippi Rivers during the height of the Civil War. The next year, they split and planned to meet in San Antonio in 1865.

From New Orleans, Lottie continued to San Antonio, arriving in 1865. She became a house gambler at the University Club, working for a Georgia family and fell in love with their son, Frank Thurmond. Gamblers at the club called her the "Angel of San Antonio" and then the jockey showed up—five years later—claiming that Lottie was his wife. She denied it.

When Thurmond, accused of shooting a man, fled to West Texas, Lottie followed, searching for him. Along the way, she gambled in Fort Concho, where she was known as Mystic Maud, and moved between Jacksboro, San Angelo, Denison and Fort Worth. Her last stop, though, was the town of Fort Griffin, also

known as Hidetown in the area known as "the flats" outside the fort's perimeter. About a thousand people—gentle citizens and rowdy outlaws, gunfighters and buffalo hunters—mingled there.

One gambler accused Lottie of cheating and dubbed her "Lottie Dinero," but she adopted Lottie Deno. Others called her the "poker queen."

She rented a cabin on the outskirts but invited no one in. People only saw her at the gambling table. One said she was "…shunned by the better class. However, she did not try to mix with them, but kept entirely to herself." Another resident of this Clear Fork area of Texas said that Lottie, "served as informant and go-between for lawmen like Wyatt Earp…"

One story goes like this: "In the midst of a game, lead started to fly. The seasoned gamblers hit the floor. When they peered over the edge of the table to see if the shooting was over, there sat Lottie, not a single flame-red hair out of place, not a speck of dust on her dress. 'Gentlemen,' she is supposed to have said, 'I came to play poker, not roll around on the floor.'"

During another fight, a fellow threw a spittoon and cold-cocked Lottie. Brought to, she "resumed her place at the poker table and started dealing again." The blow robbed her of sight in one eye and birthed an old-timer's expression, "Gone like Lottie's eye."

In 1877, the mystery surrounding Lottie Deno heightened. No one in Fort Griffin or Hidetown saw her. The sheriff entered her cabin and reported handsome furnishings. Pinned to the bedspread she had left a note. "Sell this outfit and give the money to someone in need of assistance."

Lottie, thirty-three, had found Frank and left in May 1877 for New Mexico. In 1880, in Silver City, New Mexico, they married, and she used the name, Carlotta Thompkins. Frank became a banker.

In the rise—or return—to respectability, Lottie gave up gambling and became a founding member of St. Luke's of Deming, New Mexico, where she lived out her life in much the same fashion she had begun it.

However, the Texas Lottie Deno segment of her legendary life inspired the character Miss Kitty in the TV series *Gunsmoke*. Lottie, or Carlotta Thompkins Thurmond, died February 9, 1934, and is buried in Deming next to her husband.

Chapter 5

TO INSPIRE, TO TEACH AND TO PREACH

For most of the women settlers—and women arriving in Texas in later times—schooling came first. Educating the children would be their first stamp on the new country, including the importation of European practices, such as early childhood education, as well as educating female children and blacks (in racially divided Texas), so that those without privilege could enjoy a better life with education. One, believed to be the first woman minister in the state, championed the right for women to preach. Another gained a national platform for the modern role for women at the Chicago World's Fair in 1893.

SETTLING A LAND; FOUNDING A COLLEGE

Mary Crownover Rabb

In her later years, Mary Crownover Rabb and her husband reaped success in Texas and passed it on by founding a college, Rutersville, forerunner to Southwestern University at Georgetown, a little north of Austin. In the early days, though, this sixteen-year-old bride had picked up and followed her husband into the foreign land of Texas.

Later, she chronicled this journey and experience for her children and grandchildren and, in so doing, left a picture of life in Texas in the 1820s and 1830s. In the early days, she sat at her spinning wheel to drown out the frightening sounds of Indians in the nearby woods. Later, as a widow, she would build a limestone home and welcome visiting Methodist ministers.

Mary was a Methodist, a faith that sustained her as her husband traipsed them up and down the Texas rivers—the Brazos, the Colorado and the San Bernard.

After they left Jonesborough, Arkansas, to join the Austin Colony in Texas in 1823, a year after their marriage, Mary wrote that they left with "little Babe to coum (*sic*) to Texas." Here she would find not a church, but the occasional camp meeting.

Her husband said he prayed for the safety of Mary and their growing family when he would be away for days or weeks, "although he was not a religious man, then," said Mary.

Described as tall, with dark hair and dark eyes, Mary rode into Texas on a Mexican sidesaddle atop her tall gray horse Tormenter, carrying her baby. She and her husband, John, brought in fifteen or eighteen head of "small cattle" and three or four "tolerable large ones that would make oxen." After two and a half months, they reached the Colorado River near present-day LaGrange. When it came time to cross the Colorado, Mary, mounted on her tall gray, stayed dry while the others got wet.

Her husband's father, a friend of Stephen F. Austin, had secured about twenty-two thousand acres in exchange for establishing a gristmill and a sawmill for the new colony. Rabbs Prairie still carries their name.

But Mary's husband, a peripatetic wanderer, couldn't seem to stay put, nor select prime locations. Mary, in her sparsely educated phonetic spelling, wrote: "thar was no haus thar then nore nothing but a wilderness not eaven a tree cut down to marke this plais."

At one stop, Mary made her home and spun yarn beneath a quilt and blanket tent. In another, she and the family lived through the winter in a one-walled shed. In another, they camped out in the open on an island in the Brazos River. Yet always, Mary's spinning wheel whirred, drowning out the Indian noises while the Karankawa and Tonkawa Indians helped themselves to horses, pigs and whatever food might be around.

One night while staying part of the year at an in-law's house, she awoke with a start. "The river had rose and was nerely level with the bed plais." She feared her children would drown before she could reach them.

Sometimes they moved for better farmland. Sometimes they moved because the mosquitoes were too thick. Often they moved to be closer to neighbors and family than to the roaming coastal Indians. The first dozen years in Texas, Mary and her family moved a lot, until Texas won the war to become an independent nation.

After rebuilding again following the destruction of their mill and home when the Mexican Army marched through Rabbs Prairie in 1835, Mary and John prospered in Fayette County. After four years of Mary's urging, he joined the Methodist church. In his new zeal, he became a major benefactor.

They helped found the Methodist college of Rutersville, granting it money and land. Seven of their nine children attended the school until the family made one last move to a log house on Barton Springs near Austin.

This 1849 burned-out homestead near Marshall resembles those of many Texas women settling in East and Central Texas. Scenes like this, along with the reports of killed and captured and the sounds of the raids, kept Mary Crownover Rabb awake at night, spinning to distract herself.

Mary's sons fought in the Civil War. John died in 1862. She lived out her life on the homestead, managing the property and running cattle that carried her well-known bow and arrow brand.

In 1867, she built a "fine, limestone house near the site of the old log house. From the second story porches she could look out toward the hills while remaining safely above the flowing creek waters." She outlived four of her children and wrote "Reminiscences" about the "tryals and trubles" of the untamed Texas. Mary died October 15, 1882, sixty-one years after she rode into the frontier province on a tall, lanky, gray named Tormenter.

SHE INSPIRED SCHOOLING FOR WOMEN

Rachel Linn DeSpain

Rachel Linn DeSpain didn't come to Texas until her fifty-sixth year, a farmer's widow and the daughter of an American Revolutionary War scout and minister. But when she came in 1836, she left a mark. Over the next thirty years, the woman who signed all documents with an "X" piloted a family with a faith in the Lord and a conviction that all should be educated, especially the girls.

When she set her first footprint on Mexican Texas soil in January 1836, the mother of nine had buried a daughter beside the trail, a victim of snakebite. She continued westward. A daughter and sister already lived here, and one son had sailed with the Mobile Grays to fight for Texas' independence at Goliad. Rachel rolled westward with her twelve-year-old daughter, her youngest.

Another son led the 156-member wagon train guided by Davy Crockett. However, this caravan from Alabama, called "a church on horseback," frustrated him. They stopped and worshiped God on Sunday, a practice instilled by Rachel and conducted by her son. Crockett left, fearing he would miss the fight between Texas and Mexico.

Arriving at Pecan Point on the Red River, Rachel said they should "celebrate the Lord." An oak stump draped with a buffalo hide served for a pulpit. Hunters supplied game, and Rachel supervised meals at the communal fire. After supper she would sit on a barrel, tap her feet and clap to "happy tunes that make me feel good." Her warm, ringing laughter thawed Texas' wet and bitter winter.

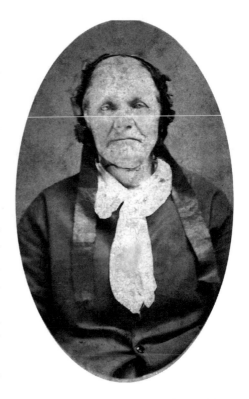

Rachel Linn DeSpain rolled into Texas with the "Church on Horseback," a wagon train of Huguenot-descended Protestants, and her teenage daughter, Hettie, shortly before the Texas Revolution. Matriarch of the family and of the church, after founding AddRan College, her grandson would credit Rachel and Hettie, saying he was "blessed with a mother and a grandmother…and the unfeigned faith that dwelt in them." *Photo from DeSpain/Fitch family.*

In March, a rider brought word of her son's death at Goliad. The next month, spring bloomed, and the grass rose "saddle skirt" high. The Texians had won at San Jacinto. The caravan rejoiced. Rachel tucked her grief inside and turned south with them toward Nacogdoches to settle and farm in the new Texas Republic. As head of a family, she received a headright of 1,280 acres and also would draw her son's veteran's bounty of 960 acres. Rachel marked her "X" in 1838 for the land grant, and she and her youngest, Hettie, or Esther, moved into a log house near Nacogdoches.

Rachel DeSpain might well have set her feet to tapping and her chair to rocking in a home like this, her first home near Nacogdoches in the Republic of Texas. Her house served as a central gathering place for the community of church people called "The Church on Horseback."

Recognizing her lack, she said, "us girls didn't go to school; boys did during winter. Our chores, cooking, cleaning, spinning went on all year."

She would be the last woman in her family left out of schooling. "We raise the little ones...we need to teach them right," she said, and "right" meant reading, writing, ciphering and understanding the "Lord's word so we know how to conduct our lives," according to Rachel.

She would advance those goals of education and faithful living within her family. In her log home, she welcomed family, church members, friends and sojourners, especially circuit-riding preachers. After dinner, her daughter played the piano and sang while Rachel rocked in rhythm with the hymns.

One day, a printer and surveyor on his way out of Texas stopped to board. Orphaned young and rooked by churchmen at the time, he had developed distaste and skepticism for church, God and churchgoers. But under Rachel's roof, a center for this small band of Christians, that attitude melted amid the warmth of her hospitality and the conviction she and her sons and daughters held. Also, he was smitten by Hettie's beauty and talent.

Joseph Addison Clark wanted to marry Hettie, and he wanted to be baptized. He won her hand, studied scriptures with his future brother-in-law and was baptized in the river behind Rachel's home.

From then on, when Clark and Hettie moved, Rachel moved with them. She horse-traded her East Texas land for parcels wherever the itinerant surveyor and newspaperman might settle. When offered a "good deal," Rachel sold and bought more, marking her "X" each time. By the time Texas entered the United States, Rachel owned good farmland in Grayson, Fannin and Hopkins Counties.

Impressed with her son-in-law and his newspapering, she loved and respected Joe Clark and insisted that Hettie "keep up." So, while Hettie went east to seminary, Rachel tended her toddler grandsons, Addison and Randolph.

Coming home the next year, Hettie advertised in the Palestine newspaper as a *femme sole*, a woman who could advertise and solicit business without her husband's signature. This was one of the losses women suffered with the change from Spanish to Anglican laws. Hettie bought a piano and began a seminary for girls, carrying out her mother's insistence that girls not be left out of education.

That insistence carried forward, beyond Rachel's

A statue of Rachel DeSpain's grandsons who carried out her teachings resides near the library of what that small AddRan College in Thorp Spring became—Texas Christian University (TCU) in Fort Worth. The school they founded, with their father, rose on Rachel's pillars of influence, a school grounded in faith, one where girls could be educated, too, and with proceeds from her land.

life. Her legacy of education for girls and boys, her faith that drew her son-in-law and her land—her treasure—would be the bedrock on which Texas Christian University (TCU) was built. Joe Clark and her grandsons Addison and Randolph, whom Rachel saw safely home from the Confederate army, would broker her land to begin the coed school AddRan College in 1873 at Thorp Springs, forerunner to TCU in Fort Worth.

TEXAS' FIRST WOMAN "SUPER"

Sue Huffman Warren Brady

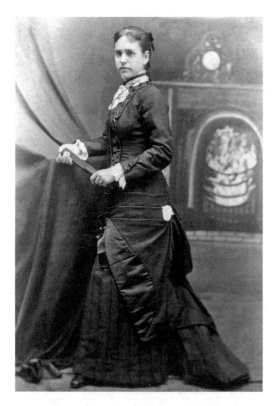

Sue Huffman Warren Brady, first female school superintendent in Texas and first public school superintendent in Fort Worth. A teenager herself, she signed on to wrest a public school system into being. *Courtesy of Fort Worth Public Library.*

"In the new South the bars of all professions and industries are thrown down, and women roam at will the pleasant fields of all forms of activity." Sue Huffman Warren Brady, a Texas schoolteacher, declared this at the 1893 World's Fair, Congress of Women, in Chicago.

Born in Kentucky, reared in Anahuac, Texas, and educated in Fort Worth at Captain Hanna's School in the Masonic Temple, she entered the first class of Sam Houston State Normal School in Huntsville in 1879 on a Peabody Scholarship. She won the scholarship based on tests and a commitment to return home to teach, an effort by the philanthropist George Peabody to train teachers for Texas' burgeoning postwar population.

A year later, in January 1881, Fort Worth hired Sue

Huffman, who graduated top in her class, to be the first superintendent of the town's fledgling and faltering public school system and the first woman superintendent in Texas. She hired six classmates from Sam Houston State Normal School to join the staff of sixteen in teaching, testing and organizing some six hundred students. In writing the outlines for the classes, reading came first and foremost for the primary grades. She set a two-part school day—8:30 a.m. to 12:00 p.m. and 1:30 p.m. to 4:30 p.m.—a nod to how long it took to go home to lunch, and she conducted monthly examinations with a week of general examinations as finals. She managed a $4,000 budget and reported to the Board of Trustees. "A successful job," the trustees and mayor said.

But political forces scuttled the public school effort the next year. Miss Huffman established a private school for the 1881–82 year, "a place of instruction, the school of Miss Huffman is the pride of the city and it deserves all the encouragement possible," read an article in the *Fort Worth Democrat*. She planned to fold her school into the public school system when it returned.

During the year, she married Ed Warren and continued to teach, an unusual act for the times. When public schools returned to Fort Worth in 1882, the city hired a man to run the district, and the budding feminist refused the principalship of a new, eight-room school building. With her husband, she founded a private school, the Warren Female Institute, where they taught and administered until he died in 1890. She competed for students with the public schools.

The urgent need for teachers and improved teachers' training created summer normal schools in Texas. Beginning in 1881 and continuing for fifty years, these short courses allowed teachers and prospective teachers to prepare for the state teacher-certification examinations. Although Sue's parents had educated her equally with her brothers, that practice ran counter to the times.

"Boys were conceded all the advantages, particularly those of education," she said. "Too often the girls stayed home from school while the boys went and higher education was not possible." She attacked that premise with zeal.

Beginning in 1883, Sue Huffman Warren organized and served as principal of several summer normal schools, beginning with the Decatur Summer Normal in that year, the Mineola Summer Normal in 1884, the Weatherford Summer Normal in 1885 and the Dallas Summer Normal in 1886. She was proud that the normal schools had been established, but even prouder that they admitted women. "At least one useful vocation was then opened to women," she said of this period when women were "faced with self-support without preparation or education."

After the death of her husband, Ed, and while rearing their daughter, Sue continued not only to teach but also to advocate for the education and training of women, which brought her to the attention of the Chicago World's Fair organizers— particularly the organizers of the first Woman's Building at such an event.

In her address to thousands, acknowledging the role of public education for boys as beneficial, she said, "but for the girls, it is a precious beacon light, beckoning them on to an entirely new life filled with hope, ambition and consolation."

Speaking as a mother, a public educator and a widow (now remarried), Sue Huffman Warren Brady had experienced the need to be independent. "Women should have the most complete equipment, the broadest and best training that the strongest institutions the country can afford…women should realize that this is an age of individual achievement," she said.

Appointed an organizer of the Texas exhibit for the Chicago World's Fair, Sue hustled publicity for the exhibit and her cause and met newspaperman Frank Brady. He reported for the *Fort Worth Gazette*, and they married in 1892. Later, Sue joined the staff of the *Fort Worth Record* and championed Fort Worth club women, the study club members who would organize later as The Women's Club of Fort Worth.

She and Brady, along with her daughter and their son, left North Texas and began a round of moves to other cities and newspapers, ending in New York.

TAGGED TO PREACH IN TEXAS

Reverend Mary Billings

Soon after the railroad laid track through Hamilton County and a small cotton farming and ranching community moved a couple of miles from the banks of Honey Creek to nestle alongside the tracks, the Reverend Mary Ward Granniss Webster arrived. She had married the Reverend James Billings, and the two were sent to preach and teach in Hico, Texas.

Licensed by the Universalist Church in 1886 in Connecticut before her departure for Texas, the Reverend Mary's third and last husband, Reverend James Billings, ordained her in 1892 in Hico. She was sixty-eight at the time and thought to be one of the earliest—if not the first—ordained woman minister in Texas.

She came to a state that had moved on from the Civil War and Reconstruction. However, skirmishes between cattle raisers and sheep ranchers—though the trail driving era passed with the coming of the railroad—continued. Like many towns, Hico thrived as a market center because of rail transportation.

It might even be said that the town boomed with the flourish of commerce brought by the railroad, probably explaining the zeal of the Universalist Church to send missionaries "to organize the church in Texas," believing the community was the center of the state. The denomination termed the mission "our State church in Hico."

Earlier in her life, the born and bred "Connecticut Yankee" had married late, at twenty-eight, to a Hartford businessman who lived about fifteen years after their marriage. They had no children. During that time, Mary's brother had become a Universalist minister, and she and her mother left the Episcopal Church to join his, a rural denomination that believed in the redemption of all people, kindred to the more urban Unitarians.

When widowed, Mary increased her activity in the church—leading the woman's association, writing and singing the hymns she had composed and writing essays and poems. And she preached. She preached and wrote about abolition and women's rights in and around Hartford while the Civil War raged.

In 1869, after the War Between the States, she married a Universalist minister, widower

When women arrived, no matter the frontier setting, they set about arranging for education and churches. This Central Texas church, seen at sunset, resembles many of the main line protestant churches in the last half of the nineteenth century.

Charles Webster, and opened and ran a stationery and bookstore in Hartford. But that did not curtail her yen for the pulpit. Mary preached, often filling in for absent ministers in the New England countryside. When widowed again in 1877, she continued her writings in national and religious magazines and her sermons about the rights and responsibilities of women to preach.

So when Mary married Reverend James Billings, the Texas state minister of the Universalist Church, her pulpit and missionary work moved to "the center of Texas," an inaccurate depiction of Texas' geographic center. At the convening of the "second semi-annual meeting of the Universalist Association of Texas," Mary opened the Dallas event singing a song she had composed, entitled "Autumn." Unlike hymns of the day that used the masculine pronoun in references, she expressed her plea and praises in

this song with the feminine pronoun—"her Watchmen…her walls…her gateways…her Councils, wise and just…"

Assigned to the resolutions committee, at the end of that gathering in 1887, Mary helped draft a resolve that the "First Universalist Church of Texas stands pledged to the cause of temperance." She would continue, from the pulpit and the pen, to urge others to "abolish this widespread evil (liquor) from our land."

It would be thirty-three years later, in 1920, before the United States adopted her position in the form of a Constitutional amendment.

The Reverend Mary's writings appeared often in the *Dallas Morning News*, stepping up her advocacy of women's roles, the rights of women to write and preach and the goal of prohibition. In her first three years in Hico, she also served as Sunday school superintendent. Then, in 1898, six years after her ordination, the Billings moved to Comanche, where her husband died months later.

After James Billings's death, the Reverend Mary returned to Hico and assumed the pastorate and pulpit of the Universalist Church. The next year, she presided over an ordination of another woman, her step daughter-in-law, the Reverend Rachel Watkins Deligren Billings.

In addition to writing and preaching, Mary continued a role begun in Connecticut—advocating for women, "though moderately," as she described her activities that did not embrace (nor deny) the budding suffragette movement. In Hico, and with her prosperity, she expanded that role by helping women finance homes and businesses, granting credit when conventional lending would not. But not for free. She charged 10 percent interest and collected or foreclosed when necessary.

By the time of her death in 1904 at the age of eighty-one, the Reverend Mary C. Billings was said "to own half the town" through tax sales, shrewd bargaining and foreclosures, as written in her obituary.

INTRODUCED KINDERGARTEN TO EL PASO (AND TEXAS)

Olga Kohlberg

When Olga Bernstein Kohlberg arrived in El Paso, she came as a college student and the bride of the Southwest's first cigar manufacturer, Ernst Kohlberg. After nearly ten years in El Paso establishing his business, he sailed home to Germany to marry Olga, a child of eleven when he left in 1875. In their new homeland, they built a temple for the Mount Sinai Congregation they founded in 1898.

But before that time, while Ernst grew his business and contributed to the prosperity of the city and its infrastructure, Olga concentrated on those often left behind—the poor, the children and the ill. A linguist and a quick study, she learned both English and Spanish, the two tongues of her new country on the Rio Grande.

From Germany she brought a sense of what any growing society needed—culture, art, medical treatment and education. In El Paso, her leadership in these areas grew this softer side of the growing town. She wanted the amenities for her children, three sons and a daughter, and then for all of the children.

Organizing and working with other women, one of her first accomplishments was a kindergarten. In 1891, the year

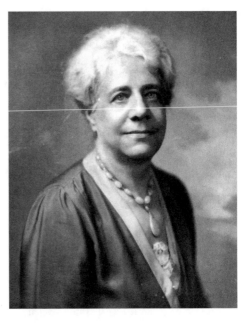

Olga Kohlberg brought German-style education to El Paso in far west Texas with the start of early childhood education. She founded the first kindergarten in 1891 and then the first public school kindergarten the following year. *Courtesy of the El Paso Public Library, Border Heritage Collection.*

that Ellis Island opened to receive future immigrants, a woman who had been here but six years opened the first kindergarten in Texas. It was private. She and others bought books and blackboards and hired a teacher from St. Louis for this first early childhood education program.

Olga had organized a Child Culture Study Circle to promote the education of young children. The next year, she and these women in her circle approached El Paso's public schools. They would give the assets and continue to support the effort if the school district would adopt such a practice.

It did and then opened the first public school kindergarten in Texas in 1893. History credits Olga with initiating this first kindergarten, a practice from her homeland. "What you learn in childhood will have a lasting effect on your life," she said.

That accomplished, Olga and her group refocused their circle, becoming the Current Topics Club, forerunner to the El Paso Woman's Club established in 1898, and it is these women that banded together to improve life for the downtrodden.

Right after founding the kindergarten, Olga learned of a misfortune that struck her heart. A sick man died on the platform of the railroad station. Olga brought together women to form the Ladies' Benevolent Association, and this group opened the first hospital in El Paso in a residence.

In 1895, a fledgling library opened with few funds from the city. Olga stepped in to instruct the librarian to buy the best, and then she supported that effort financially and with leadership. Similarly, when the city council funded three parks with only $100, Olga, leading the woman's club, said, "We will plant, dig and weed." The result? The city's San Jacinto Plaza became a garden spot.

Babies, "almost dying" from the heat of the Chihuahuan Desert, coming off two years of severe drought, ignited another cause for the woman who would become El Paso's leading philanthropist. Olga had arrived in a drought in 1884 and in the comfort of her home had weathered seventeen such dry ups since arriving. Others weren't so fortunate, and she was alert to their plight. She founded the Cloudcroft Baby Sanatorium in New Mexico in 1911.

The baby sanatorium opened in June, a year after a drunken tenant had murdered Olga's husband. The sanatorium took the babies up the mountain into the cool pines, where a young doctor from North Carolina, who became Olga's son-in-law, took care of the infants until it was safe to go down the mountains.

Honored in 1972 with El Paso's Hall of Honor Award thirty-seven years after her death, the presenter said of Olga Kohlberg: "Those of us who knew her, whose lives she touched, can vouch for her indomitable spirit, her dignity, her tolerance, her integrity, her calm, courageous manner, and her persistence in working for the best for the community."

Said to be "zealous" by the writer of her obituary, "she graciously acceded to their wishes, never harboring any ill feeling when the majority in a group voted against something Olga had sponsored."

Olga Bernstein Kohlberg served as president of much she had begun for the city of El Paso: the library for over twenty-five years, the county hospital and the evolvements of the Woman's Club.

SHE WRESTED A BLACK COLLEGE FROM THE PLAINS OF INDIFFERENCE

Artemisia Bowden

Born in 1879, the first of five children, Artemisia Bowden soon experienced a loss of family. Young when her mother died, her family's local priest in Brunswick, Georgia, suggested that Artemisia be sent to St. Augustine's School in Raleigh,

North Carolina. The priest must have recognized her quick mind and perhaps the benefit of receiving an education instead of taking on the responsibility for younger brothers and sisters.

Artemisia's father agreed. She attended St. Augustine's and graduated in 1900. With her Normal School teacher training, she spent a year at a parochial school and then another at a normal and industrial school, setting her feet on a path toward Texas.

Looking for "a black woman imbued with a vitality, spirit, and vision of St. Philip's School becoming a great institution," San Antonio's Episcopal bishop found Artemisia. She arrived in San Antonio in 1902, at twenty-three, to take the reins for the school that she would guide for over fifty years, raising the standards of education in Texas for black children.

First she organized St. Philip's into three departments—primary, secondary and vocational--a success until vocational education entered the public school curriculum. St. Philip's "high" tuition of fifty cents a month for primary and seventy-five cents for secondary education couldn't compete with the city's free education.

So she recruited students from outside the city. Artemisia rented a house near the La Villita campus, and St. Philip's first boarding students trickled in. Also opening in 1907–08 was the Normal Department to educate Texas black elementary school teachers.

Before that, Artemisia had brought in her beloved sister to instruct at the growing school, and she enjoyed the closeness of family for the first time since leaving home. But Mary died. Struggling with this grief, Artemisia had to find a teacher to replace her sister in the classroom while also contending with the urgency of raising money.

Before World War I, the Episcopal Diocese of San Antonio struggled and, with the prejudice of the time, directed its funds for St. Philip's to schools for

Artemisia Bowden arrived in Texas in 1902 to guide an Episcopal school for black children in San Antonio, a role she fulfilled and grew over fifty years. *UTSA Libraries Special Collections from the Institute of Texan Cultures.*

whites. With church operating fund sponsorship gone, Artemisia campaigned for money everywhere.

"Miss Bowden wasn't afraid to ask any person from whom she thought she could get money…to keep St. Philip's open," an instructor said. The school moved to San Antonio's east side, and Artemisia stepped up fundraising, getting an annual grant from the American Church Institute for Negroes, building a firmer financial footing.

Next came fulfillment of her dream—the creation of St. Philip's Junior College. She sold the vision to San Antonio's mayor, chamber of commerce and businessmen who pledged support. The new black junior college opened in 1927.

The Great Depression soon nibbled at the school's foundation, causing the Episcopal church to consider foreclosure on the property. Meanwhile, "Artemisia would call on me regularly and I'd give her five dollars or ten dollars toward teacher salaries, a St. Philip's board member said. During summers, though, she continued her education, earning a bachelor's degree in 1935 and an honorary master's from Wiley College in Marshall and continuing graduate work in education and social work. This brought her and St. Philip's recognition and financial support from local and national organizations.

After the Depression, the Episcopal Diocese restructured loans, paid off St. Philip's debts and then set the school loose.

Two years later, Artemisia persuaded the San Antonio Independent School District to incorporate St. Philip's into the district's junior college system. She became dean of Philip's Branch, serving the black community in numerous projects.

Appointed to the Texas Commission on Interracial Relations in 1947, she led the effort for a black nursing unit at the city's hospital, a park for black residents, the "East End Settlement House" and the State Training School for Delinquent Negro Girls at Brady.

In 1954, at seventy-five, Artemisia retired as dean emeritus. Two years later, Tillotson College in Austin awarded her an honorary doctorate. The National Council of Negro Women recognized her as "one of the ten most outstanding women educators in the country."

Also, she was a member of the Southern Conference of Christians and Jews and of St. Philip's Episcopal Church in San Antonio.

When she died in 1969, the *San Antonio Express* wrote that her "intelligent mind and sensitive soul put her in the forefront of efforts to raise the educational level of her community in an era when not much was being done about that work…she taught human understanding and intellectual advancement as well as the textbook learning that was her business."

Artemisia Bowden's name lives on as Bowden Elementary School in San Antonio and as the Bowden Administration Building at St. Philip's.

Chapter 6

SHHHH! WOMEN IN BUSINESS

Beginning in the republic's days, Texas drew female entrepreneurs, sometimes alone, sometimes with husbands and sometimes despite their husbands. They applied the exactitude of finance with the strategies of growing and mushrooming original holdings. Largely, they did so in hiding, for in the early days, when this chapter begins, women who operated businesses in public were unseemly to the population.

HOSTAGE RESCUER TO HOTELIER

Mary Dodson Donoho

Mary Dodson Donoho probably stopped at the hollowed old oak at Council Grove, Kansas, to post a letter back home to her mother in Missouri. That was the post office on the Santa Fe Trail, and Mary was the first woman to go out on the Santa Fe Trail on a wagon train that left Missouri for Santa Fe, New Mexico, in 1833.

She and her husband, Bill Donoho, planned to profit from the spirited fur trade by setting up a hotel and trading post in Santa Fe. Mary nursed her nine-month-old daughter and bushwhacked a team of oxen. In the company with 185 travelers, she was the only woman.

In Santa Fe, she operated the American Hotel, where the La Fonda now stands, in a town where women smoked, drank and gambled. Then Texas won independence from Mexico and claimed New Mexico. New Mexicans battled the Texas claim, and Anglos like the Donohos fled.

In Clarkesville, Mary Donoho built up properties, her hotel and home around the square and prodded the citizenry to pay for fire protection.

Mary, Bill and their three children returned to Missouri, taking rescued Indian hostages with them. Mary fed, clothed and nursed these women and listened to their accounts.

One of the Texas captives, Rachel Plummer, wrote, "I have no language to express my gratitude for Mrs. Donoho…anxious to make me comfortable…assured that everything should be done to facilitate my return to my relatives…I still owe her a debt of gratitude."

From there, Clarkesville beckoned, booming with the flood of emigrants into independent Texas. It needed a fine hotel. In 1839, the Donohos rented a double log, two-story house. Two years later, they bought a long house on the square and opened the Donoho Hotel. Over the next four years, Mary bore three more children.

By 1845, Donoho had purchased settlers' headrights and owned 10,000 acres in and around Clarksville. He received 4,600 acres in Young County from the Republic of Texas, compensating him for rescuing captives.

But in that year, he died without a will, leaving Mary, a widow at thirty-seven with five children and a business, land rich and cash poor. She applied to the court for permission to sell land and slaves for cash in order to keep operating the hotel and to support her children.

Six years later, the estate finally settled, she enlarged her hotel, already known for fine food, excellent hospitality and comfortable rooms. A large bell mounted outside rang fifteen minutes before meals.

Mary served liquor in her tavern and hosted balls at the Donoho Hotel, "one of the most commodious in the State, affording a large number of single rooms and ample accommodations...pleasantly situated...especially comfortable," her ad read.

"Strong and determined," her son described Mary, she responded to setbacks. A fire threatened her hotel, and she used this to fan political flames to organize a fire department. The Butterfield Stage stopped at her front door where a historical marker now stands. Inside, she sold passage for ten cents a mile. When a stage traveler passed through and died a few miles and days later from smallpox, Mary advertised that "despite rumors, the traveler had not stayed in the Donoho Hotel...patrons' minds could be eased...there was no contagion."

The hospitality queen, she hosted all-night graduation dinners and balls for her children at the Donoho. "The parties and balls given there were among the greatest pleasure evenings in the history of the grand old town," one settler recalled.

A wealthy hotelier, respected and influential, Mary not only held onto the land Donoho had acquired, but also continued purchasing acreage, cattle and horses. She tripled the family's worth to $41,000 in 1860.

She reigned through the rapid changes of the republic, statehood, the Civil War and Reconstruction, but her family dwindled. Most of her daughters died in childbirth, one in childhood.

Sparing her remaining family the estate wrestling she had experienced, Mary wrote a nine-page detailed will, naming her son and three grandchildren heirs. The daughter's children would receive the first land Donoho had purchased in 1840, over a league along Boggy Creek. One granddaughter would receive her "five-year-old dark bay mare" and 156 acres. Her son's share included town lots, land and the hotel, with instructions that his four children should inherit from him. Each of her seven grandchildren was to have one of the hotel's prized feather beds "when they reached age twenty-one."

"Complaining of a difficulty in getting her breath," her son said, she "quietly and without a struggle passed away," in January 1880, at age seventy-three.

Like others of her era, she had embraced the frontier's bawdy nature, the mingling of cultures and then the conservative restraint ushered in by settlement and civilization along the Red River. A staunch Baptist at her death, she was buried in the Baptist Cemetery, alongside her husband, in Clarkesville, a corner of the state where women did not smoke, drink or gamble.

BALANCING BUSINESS AND CHILDREN—A HIGH WIRE ACT IN THE 1850s

Sarah Horton Cockrell

Almost forgotten, Sarah Horton Cockrell, "Texas' first woman capitalist," put Dallas on the economic map and ensconced her children in society.

But it was not always that way. Not in 1847, when she married and lived in a tent on Mountain Creek while her husband built a cedar log house, and she traded foods with Indians. Not in 1858, when she took over the family business after the town marshal shot and killed her husband, Alex, when Alex tried to collect a debt from the sheriff.

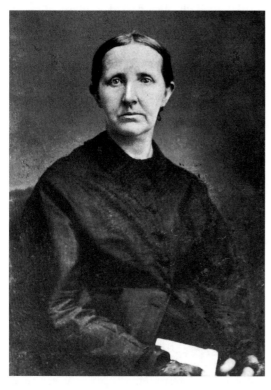

Sarah Horton Cockrell, in her fortieth year, "was not a devotee to society but devoted her life to her children and to her business. It was her courage and business acumen that pushed Dallas forward when water and fire had snapped its strength," her daughter said.
Courtesy of DeGolyer Library, Southern Methodist University, Dallas, Texas, A2002.2335.

Before this tragedy, Sarah and Alex had begun a partnership. He was a trader, trapper and hunter. She could read and write and developed a head for business. He purchased a headright along the Trinity River and acquired a ferry license. The Cockrells moved into Dallas, a town of 250 in 1852, and opened a construction business making bricks.

In 1854, they built a covered wooden toll bridge over the Trinity, replacing the ferry. Two years later, they built a two-story building. They owned a sawmill and in 1857 began building a brick hotel.

In all of these operations, a son said, Sarah was Alex's "advisor, counselor…she wrote down everything in her day book." When he was killed, she knew the ropes,

and despite her grief and the sentiment of the times that women should not be seen in business, she took charge. She even sued the marshal for the debt he killed Alex over and collected.

Sarah operated from home while tending her five young children. From there, she completed the hotel, naming it the St. Nicholas. She hired a man to manage it, to conform to the standards of what was appropriate for the time. The St. Nicholas burned in 1860 in a fire that fairly razed Dallas, and a flood swept away her bridge. Despite these personal and business disasters, Sarah forged ahead.

She turned her two-story building into another hotel and named it Dallas Hotel. She brought the ferry back into service. Dallas businessmen schemed to prevent her from building a new bridge, but Sarah lobbied—through friends—for the charter and won in 1860, though it would be a dozen years before she could build.

As cruel as these early years were for her, by post–Civil War, she had thrived. In Dallas' boom of 1871–72, Sarah's latest hotel, the St. Charles, prospered. That same year, she bought into the flour milling business. However, Sarah's greatest contribution was the access that her ferry and bridges gave Dallas, connecting it to the main road in North Texas. By 1871, she convinced one hundred investors to put up the $55,000 needed to build the new iron suspension bridge the next year.

One of the ways Sarah Cockrell pushed Dallas forward, one that symbolized her efforts to put Dallas on the transportation maps, was the construction of an iron bridge over the Trinity River, replacing the fire-ravaged wooden bridge. *Courtesy of DeGolyer Library, Southern Methodist University, Dallas, Texas, A2002.2335.*

Sarah continued to run her businesses from her home. Workmen and businessmen called on her there. Employees delivered tolls from the ferry and bridge there. People came there for loans. Brick masons paid her for the clay they took from her bottomlands there. She made deals there.

Yet it was also home where she cooked, quilted and entertained. In 1870, her wine won a prize at the fair. She bragged about her new stove with multiple burners. Friends and family enjoyed her hospitality. She hosted parties and balls, especially as her children grew up.

They came first. Some say she indulged them, and she lamented their leaving when they ventured east to school. But she had promised Alex that they would be educated. "I would never die satisfied," Sarah wrote, "if I did not comply...with my promise to their father." She had hidden from them that he was illiterate. Sarah wanted her children to be accepted among Dallas' finest families.

But the desire for social acceptance never caused her to duck a confrontation. In her thirty-four years as a widow in business, she sued or was sued thirty-six times. A businessman said, "She is a woman who could always speak her mind but never use too many words to do so."

When her sons and son-in-law began working in her businesses, she concentrated on real estate. In 1884, the Sarah Cockrell Addition opened as a residential subdivision in today's downtown Dallas. The next year, she built a five-story office building. In 1889, she made fifty-three separate land transactions, with another twenty the next year and twenty more in 1891.

And she gave. She loaned people in need money and forgave it if they couldn't pay. A founding member of First Methodist Church of Dallas, she gave land and money to build it. A stained glass window commemorates her gifts.

When Sarah Cockrell died in 1892, the city of Dallas mourned. A council proclamation noted her "nobility of soul, unostentatious charity and hearty hospitality." City government closed for an hour for her funeral, the councilmen attending as a group for one they called "the first woman capitalist."

MERCHANT, BANKER, TIMBER QUEEN

Sallie Gibbs

After leaving college in 1863 and waiting out the Civil War in North Carolina, Sarah Elizabeth (Sallie) Smith headed for Texas. She had first visited Texas in 1859 when her parents moved their plantation to Montgomery County from North Carolina, and she pleaded to join them, drawn by the romance of the

frontier adventure. Her father agreed, but insisted that she return to Greensboro (NC) College for Young Ladies.

On the move to Texas in 1859, the women in the family rode overland in high-wheeled buggies. They called it a camping trip. Slaves hurried ahead to ready tents with carpeted floors, feather mattresses with sapling boughs for springs and steaming pots of food for the family's arrival. Complying with her father's decree, Sally returned to North Carolina by boat and graduated valedictorian. In the last two years of the Civil War, she created ruses of contagious disease to keep away Union troops.

After the war and able to travel, when she reached Texas, Sallie was introduced to Sanford Gibbs of Huntsville, a widower twenty-five years her senior. Six months later, they married. Sallie's father provided a dowry of "thousands of dollars," which helped Gibbs broaden his successful business, Gibbs Brothers Mercantile, first established as Gibbs & Coffin in 1841.

For the first dozen years of her marriage, Sallie bore six children and concentrated on rearing them to be smart, proper and caring Methodists, a practice she continued through the next generation. A granddaughter remarked that Sallie's views, expressed as the reigning matriarch, made her uncomfortable to be around.

Her husband kept her abreast of business matters. He respected her abilities, just as her parents had when they recognized her precociousness and employed a tutor when she was four and then sent her off to college at fifteen. So it was no surprise that four days before his death, Sanford signed his will, leaving Sallie "full power to sell, exchange, invest, and reinvest…according to her own judgment and discretion."

She was to control the Gibbs's fortune, $282,627 at his death in 1886, with one major caveat: if she remarried, she would receive only a child's portion of the estate.

To manage the business and rear six children, Sallie subdivided and operated from behind a growing battery of men who dealt in public matters for her on behalf of Gibbs Brothers Mercantile. She created subsidiaries, three different businesses with managers, her method for skirting the prejudice against women in commerce.

With minor children to rear and teach her ways, Sallie could not travel to oversee distant properties and asked a Huntsville gentleman to head the land business. That relationship lasted the thirty years she operated Gibbs Brothers Mercantile, which by 1900 would surge into the exploding timber business. Sallie sold quick-growing pine to sawmills but retained the slow-growth hardwoods and mineral rights.

Clerks at Gibbs Brothers Mercantile helped her run the store, begun as a rural general store with supplies for the kitchen and the field. Sallie's older sons

Sallie Gibbs bore the moniker "Timber Queen" after she took over the family business when her husband died. Like other women of the time, she set up men to be the public face of her businesses, but she was boss in Huntsville, Texas, and the surrounding pine tree and Big Thicket area. *Courtesy of the Sam Houston Memorial Museum.*

went to work there, learning and keeping an eye on the business, with oversight by Mama.

The mercantile's practice of loaning money to farmers until they could repay it with the next crop, collecting the interest and serving as a financial nerve center for Huntsville and Walker County were the roots of the next business. Sallie and her sons organized Gibbs National Bank in 1890.

She controlled 266 of the 500 shares of bank stock and held a seat on the board. Her oldest son was elected president. Historians acknowledge that while Sallie was not the first woman to "sit" on a bank's board of directors, she was the first one to participate. At her memorial in May 1918, the other directors said that she provided "the kind of counsel and advice… [that] contributed greatly to the success of the bank."

Through financial support when needed, Sallie also continued the community services begun by her husband and his partner: the state prison system, secured for Huntsville in 1848; the first normal school in Texas in 1879, which later became Sam Houston State University; and First Methodist Church. Her home and those of her children became architectural showpieces for Huntsville.

When her health deteriorated, Sallie worried about how to distribute the Gibbs fortune. From 1886 to 1917, she had tripled the estate.

Rather than divide the company into six parcels, weakening it, she passed it on as one unit. All voted on decisions. All shared in the profits. Those running the businesses would be paid a salary in addition to their profits.

This decision bucked inheritance traditions, but Sallie convinced her children to go along. As a result, Gibbs Brothers and Company continues in business, acknowledged by the state as "the oldest in Texas under original ownership."

Ex-Slave Corners Dallas Real Estate

Hope Thompson

Over a steaming wash kettle on North Texas' sweltering prairie, Hope Thompson celebrated one victory: freedom. Born into slavery "about 1826," according to Hope, she and her husband and daughter came to Texas during Reconstruction. From the laundry shed of a South Carolina farm, she had a trade. In Dallas, joining freed slaves who flocked there after the war, she picked up businessmen's clothes, washed them in a pot over a fire, hung them out to dry and ironed them wrinkle-free with a flat iron.

But Hope would be more than a washerwoman in Texas. She supported her family and salted away the coins, along with some real estate tips, while collecting and delivering the laundry. By 1868, she made her first financial move, having eyed a piece of thickly wooded property. She wanted it for her home, her homestead amid the tall elms. But at fifty dollars, it cost a lot more money than she had.

One of the men she laundered for, a banker named William Henry Gaston, encouraged her, suggesting that she could pay him back by doing laundry. With the how-to settled, Hope made the offer, and in predominately white Dallas, no one had a problem with her buying the property. That is, in 1868, they didn't. The two streets that bordered her lot were covered with six inches of silt and dust in dry weather and "deep-gutted with ruts and chuck holes after the slightest rain." Hope marked her "X" on the deed, and she and Isaac built their home on their land between what are now Live Oak and Elm Streets.

But then the railroad came through just yards away. Hope's property ran two blocks north of Commerce Street and a block south of what would become Pacific Street after the T&P Railway chugged into Dallas. Elm Street had become the corridor for cotton trade with the railroads that crossed in Dallas in 1872–73, the Texas and Pacific and the Houston and Texas Central railroads.

In the next decade, this mercantile area also flourished when Dallas emerged as the world center for the leather and buffalo-hide trade. General stores opened up alongside the tracks on some of Hope's real estate. A merchant district grew up, and the dirt road in front of her new home clattered with horse-drawn traffic.

The population soared, building Dallas into the largest city in Texas in the late 1880s and early 1890s. Hope had picked a site that would boom with Dallas' post–Civil War growth. The land skyrocketed in price.

Hope's assets soared. Her husband wanted to sell and get the cash, and according to court records, a Dallas man who wanted Hope's land told Isaac to "go home and beat her until she'd agree to sell." Later, in court testimony,

Hope said, "Every time he whipped me it was because I refused to sell any of my homestead."

Saying, "I was afraid he'd kill me," Hope divorced Isaac in 1871, and he moved out of the county. Called "Auntie Hope" by the bankers who accepted her "X" on deeds while she enlarged her real estate investments, she remained in Dallas. From 1870 to 1891, she continued buying tracts of land in the midst of white landowners in the increasingly segregated Dallas.

The land Hope bought in 1868 for $50 was valued at $25,000 twenty years later. She no longer needed to wash clothes.

With this soaring value, however, greedy eyes targeted it. One family, father and son, the Puttys, sued in successive decades. In the seventies, during Reconstruction, black jurors overturned the Puttys' claim. Ten years later, so did white jurors. In April 1884, Hope won the final Puttys' lawsuit. The next year, her real estate appraised at $35,000, and she sold a fifty-foot lot fronting Elm for $5,000. Over a period of ten years in the 1880s, several others sued, but Hope won in the courts, keeping title to her real estate.

A Dallas newspaper wrote, "When purchased the property was densely wooded but by 1888 it was in the heart of a promising city and is a fair illustration of the progress of Dallas."

During Dallas' centennial year of 1949, Hope Johnson's land was worth $250,000.

Today, glass and stone buildings tower over the intersection of Elm and Live Oak at Ervay where the former slave bought her first lot. Marking her "X," she held on, leaving prosperity in downtown Dallas real estate for her daughter and son-in-law. Hope had lived with them until her death "about 1894 or 1895," according to her son-in-law.

SHE CARRIED A BIG STICK

Clara Driscoll

A red-haired girl with reddish-brown eyes and the granddaughter of two Texas Revolutionaries, Clara Driscoll learned to ride, rope, shoot and speak Spanish on her father's ranch, yet she spent decades away. Born on Copano Bay near present-day Bayside in 1881, her parents sent her to New York for school at age ten, and then to the Chateau Dieudonne, a French convent near Paris.

For her eighteenth birthday, her mother gave her a trip around the world, during which Clara discovered Northern Italy's architecture. On this adventure, her mother died in London, leaving Clara to sail home alone.

Returning to Texas, Clara settled in San Antonio. She danced to Mexican folk music, conversed in fluent Spanish and was shocked at the Alamo's crumbling state. Familiar with how European countries took care of landmarks, she joined the preservation fight.

"It is our Alamo," she said, "…and how do we treat it?…Are [we] so careless of its existence?"

Although a teen, Clara roamed the Texas capitol buttonholing legislators who agreed to spend to save the Alamo. But the governor nixed the bill.

When the Daughters of the Texas Republic, which Clara joined, couldn't come up with the funds, she wrote a check and then sought her father's counsel on whether $75,000 was a fair price.

He agreed it was but asked, "Do you know anyone who will throw that much money away?"

"Yes," she said.

"Who?"

Clara Driscoll, twenty-two-year-old "savior of the Alamo," wrote a check for $75,000 to save the crumbling battle site. *Courtesy of the Robert Driscoll and Julia Driscoll and Robert Driscoll Jr. Foundation.*

"Myself. I have the money and I don't care whether the state repays me or not."

Newspapers trumpeted. A twenty-two-year-old Texas woman bought the Alamo, launching her reputation as "Savior of the Alamo," and the fame drew her to New York again, this time as a novelist and playwright.

She turned her research on the Alamo into a novel, *The Girl of La Gloria*, published in 1905, followed by a collection of short stories, *In the Shadow of the Alamo*, and then she wrote her comic opera *Mexicana*, which ran on Broadway for six months in 1906.

That year, she married newspaperman Hal Sevier, built her first Italian style mansion at Oyster Bay, Long Island, and dazzled New York society.

When Clara's father died, she and Hal returned to Texas, settling in Austin. They built another Italian mansion, called Laguna Gloria, on the lagoon of the Colorado River that Stephen F. Austin had first claimed. They spent World War I in Chile, though, not returning to Laguna Gloria until 1920.

Two years later, Texas Democrats elected Clara their first Democratic National Committeewoman, a role she held for sixteen years. She supported fellow Texan John Nance Gardner, who landed on the national ticket due to her money and political savvy.

"Politicians learned to respect her. She could drink, cuss and connive with the best of them, outspend practically all of them," *Time* magazine reported.

In 1929, when her brother died, Clara took over the 100,000 acre ranch, sixteen oil wells, three gas wells, three cotton gins and numerous real estate holdings in Corpus Christi, all of which she ran from her office in the bank. President and sole owner of Corpus Christi Bank and Trust Company, she also was the largest stockholder of Corpus Christi National Bank.

Others went broke during the Depression, but Clara doubled the Driscoll fortune. She is said to have "wheeled and dealed and made million dollar agreements." When Hal was appointed ambassador to Chile, she went south with him again. But back home in 1935, Clara sued for divorce and her maiden name.

She built the Robert Driscoll Hotel in Corpus Christi in 1941, a time when little construction was taking place, but it put Corpus Christi on the map as a destination tourist city. She named the hotel for her brother and then occupied the penthouse. But home would be ranch headquarters, where she liked to "get away from things."

At sixty-two, Clara Driscoll donated her Austin mansion Laguna Gloria to the Texas Fine Arts Association for an art gallery. "Half my heart went out when I gave it," she said.

While she continued to support the Alamo, women's clubs and Democrats in the one-party state, she planned a legacy. In her will, the Driscoll estate would build and operate a children's hospital in Corpus Christi to provide free medical care for underprivileged children. In the '40s and '50s, children were being struck with polio and tuberculosis. Eight years after Clara Driscoll died at sixty-four in 1945, Driscoll Children's Hospital in Corpus Christi opened and continues its mission today.

Texas honored its globetrotting granddaughter. Her body lay in state in the chapel of the Alamo. "For three hours, thousands of Texans paid their last respects" to the "Savior of the Alamo" in 1945.

The nation's vice president, Speaker of the House, senators, congressmen and a future president served as honorary pallbearers for the Palo Alto Ranch's cattlewoman, her favorite title.

Chapter 7

SCIENCE AND TECHNOLOGY FIRED THEIR PASSION

B eginning in 1895, Texans gaped as women conquered new, sometimes dangerous, advances in science and technology. Medicine drew them. Advances in transportation from saddle horse to flight carried them. Two pioneers took to the skies over Texas and the world. The doctors achievements brought healing to many, lessened the torture of pain during surgery, improved sight and advanced knowledge of the state's famous flowers, acquiring recognition for precision and compassion. In aviation, they carried the mail, trained aviators and entertained gaping audiences in Japan, China and England, notching firsts along the way.

FIRST FEMALE RAILROAD DOC

Sofie Herzog

At fourteen, an Austrian-born doctor's daughter married a Vienna surgeon and started her family of fifteen children. When he accepted a New York City practice, she joined him and began studying medicine. At age forty, Sofie Dalia Herzog returned to her homeland long enough to earn her medical degree from the prestigious University of Graz in 1886.

When her husband died—she'd practiced medicine with him for nine years—Dr. Sofie Herzog, age forty-nine, left Hoboken, New Jersey, to visit her daughter and new son-in-law in Texas.

The frontier life and its opportunity took hold. Dr. Sofie Herzog opened her office in Brazoria in 1895, but it took a spell for the people to get used to her.

She shocked Brazorians with her short hair, the man's hat that she wore and the split skirt she traveled in, riding horseback astride instead of sidesaddle, how ladies traditionally rode. People said she would hop on her horse and fly down the streets of Brazoria to a patient. At first, she patched up gunshot wounds. Her earliest patients were bandits, those shot in feuds and those wounded in barroom brawls. She operated on accident victims and in time delivered babies. In doing so, she became "Dr. Sofie" in the minds and hearts of people around Brazoria.

Dr. Sofie had become a frontier doctor, her surgery skill well noted. Those who recovered spread the word. She kept the slugs she dug out of her patients as souvenirs. At one point, she gathered these bullets and took them to a Houston jeweler. He strung twenty-four of them on a necklace, linked with gold. She wore this and insisted it be buried with her when the time came, and it was.

Rather than criticize Brazoria for its lack in education, hospitals or culture compared to her previous homes, Dr. Sofie thrived. Her outspokenness and leadership in community life was tolerated, if not welcomed. She combined skill and tenderness as a physician with a head for business. Alongside her medical office, she established a drugstore, sometimes conjuring up her own pharmaceuticals, searching for solutions to diseases in an area oft plagued by malaria and yellow fever.

She also built the Southern Hotel across from her office and drugstore. The hotel emerged and remained a social and political center in the town. Invested heavily in land, Dr. Sofie grew quite wealthy.

But that success didn't sidetrack her from her zeal to deliver new life or mend the sick and broken. In the early 1900s, the St. Louis, Brownsville and Mexico Railway laid track in South Texas, and with each mile, accidents and illness struck the work crew. They called on Dr. Sofie, who rode her horse along the trails and into the woods to those who needed her in the construction camps. Once the trains ran, folks told of seeing her, clutching her hat with one hand, her medicine bag with the other, while a crewman pumped a handcar with all his might. Day or night, she traveled by any means available—boxcars, train engines or handcars.

Her son-in-law bought her a pistol for protection, but she refused, preferring her fireplace poker, which she used just once—against an alligator.

She had long since overcome the objections to her "peculiar ways and manner of dress" and prejudices about a woman doctor. Her skill and caring overrode early prejudice. With the earned reputation that she took pride in, an opportunity arose. Her railroad patients and their bosses proposed her for the job of chief surgeon of the St. Louis, Brownsville and Mexico Railway. She got it. But when a New York-based executive found out that Dr. Herzog, his new chief surgeon, was a woman, he wrote, "I know you'll resign."

"I'll keep this job so long as I give satisfaction. If I fail, then you can fire me," Dr. Sofie fired back. She asked "no odds" because of her gender and remained chief surgeon of the railroad for over twenty years, until she resigned a few months before her death.

Outspoken by nature, she quarreled with the Catholic Church and then built the first Episcopal Church in Brazoria, becoming Episcopalian.

In 1913, still chief surgeon for the railroad, as well as an entrepreneur and investor, she married a planter and moved into his house, seven miles from town. She was sixty-seven; he, seventy. She commuted to her office in town in her new Ford runabout, the first in the area.

At seventy-nine, in 1925, a stroke felled the physician mom who came to Texas for a visit and stayed thirty years, the nation's first woman railroad chief surgeon and a town leader.

PIONEER IN TEXANS' VISION

Dr. Mollie Wright

Mary Elizabeth (Mollie) Wright, "too little to walk," rode a Spanish pony to and from school in 1881. She attended a country school in Pleasant Valley, near present-day Temple. Fifth of seven children, Mollie's older brothers heckled her when she bested them in spelling. In the one-room school, students took spelling only after proficiency in the core curriculum of reading, writing and arithmetic.

Yet with school came headaches, and over the next ten years, they increased. Riddled with pain, she was forced to drop out in her freshman year at Baylor Female College, now University of Mary Hardin Baylor.

The next year, 1892, was busy. She married Walter David Armstrong, a watchmaker that she met while in Belton. She moved to Brownwood in a horse and buggy, where they opened Armstrong Jewelry Company. By year's end, she bore her only child, a son, Wright.

In the 1890s, people bought "spectacles" in jewelry stores, trying them on until a pair fit. At the store, a traveling salesman studied Mollie's eyes and asked her about headaches. He recommended glasses.

"I would not wear them for I would look like the very devil," the teenager said.

He explained the relationship between nearsightedness, eyestrain and headaches. Two weeks after her first pair, Mollie had no headaches.

After that, "I warted nearly every doctor in town...Doctor, do you have anything on eyes?" Not much was known.

Another traveling man came through Brownwood selling a correspondence course in the sciences of the eye. She enrolled and excelled. Kellum and Moore School of Optometry invited her to Atlanta. In 1898, she packed up her son for Atlanta and studied there for two months. A faculty ophthalmologist, impressed that a woman would study optometry, let her observe his eye surgery and explained each step.

"It was the grandest privilege…it has been a great help to me all through my practice," she said.

Returning home, Mollie opened her optometry practice on September 1, 1899, in the Armstrong Jewelry Company. "When I came back to Brownwood, people said, 'Just put the glasses here and let me pick a pair out.'"

So, Mollie—the first optometrist in Brownwood, the first woman optometrist in Texas and the second in the nation—locked the spectacles in the vault. No more trying on without an exam.

Even with free exams, patients only trickled in until an inebriated railroad engineer visited. He couldn't see well. Mollie Armstrong fitted him, and he bragged about her up and down the Santa Fe tracks.

She sought more knowledge. Taking Wright with her, she studied in Kansas and then Chicago, earning both a bachelor of optometry and doctor of optics degrees in 1904.

On her return, peers elected "Dr. Mollie," as she became known, to her first of many offices in the Texas Optometric Association (TOA). She took the reins of TOA from 1923 to 1925. It would be seventy-six years before another woman would serve as TOA president, though Dr. Mollie Armstrong encouraged young women.

Her TOA presidency coincided with a Bell County school chum's inauguration as Texas' first woman governor, Miriam A. (MA) Ferguson. Governor Ferguson appointed Mollie to the Texas Optometry Board of Examiners in 1925, where she served until retiring in 1951. As the governor's appointee, state examiner and TOA president, she nudged legislators for stiffer laws for optometrists and to support optometrists in spats with the medical doctors.

Also, she had become the first woman Democratic Executive Committee member from her region.

"All politicians in the state knew 'Dr. Mollie' and curried her favor for support," wrote a colleague. Another said, "She was the best known Texas optometrist throughout the nation" and the first woman certified by Optometric Scientific Foundation in Boston.

Continuing her foresight, she put together a liability insurance policy for optometrists nationwide.

With a reputation for getting things done, Dr. Mollie loved and organized conventions, national and state. In 1927, she gathered a team of optometrists. "You put on the show and I'll be the hostess," she said. And did.

A hometown advocate, she brought the TOA convention to Brownwood in 1933 and the Texas Democratic Party convention in 1948, the year she sold Armstrong Jewelry Company. Walter had died in 1942, months after their golden anniversary.

With the same energy that she played the pump organ at First Methodist Church, she kept "moving things around in my hometown," as she called it. She worked for a public library and paved sidewalks, raised money for policemen's uniforms and for college scholarships for girls.

Dr. Mollie Armstrong practiced optometry sixty-three years, until 1962. In 1964, she died at age ninety, eulogized in Brownwood and across the state as "a true pioneer" and "beloved."

Pioneer Doc Urged Girls to Dream

Dr. Claudia Potter

A young Denton County farm girl dreamed large. Born in Little Elm, Texas, in 1881, she said, "All my life from early childhood I had said I was going to be a doctor." At her retirement in 1947, Dr. Claudia Potter encouraged girls. "We women that pioneered in this field like to see the good work go on."

Indeed, she broke paths as both a woman in a "man's field" and in the technology of her specialty. Graduating as valedictorian from Denton High School in 1900 and "not discouraged" by her parents, she attended the Medical Branch of the University of Texas, the only woman in a class of twenty-three. "I used all my feminine wiles," she said, "to overcome the prejudice." She graduated in 1905 and served an internship at John Sealy Hospital in Galveston, becoming the only physician practicing full-time anesthesiology in Texas and the first woman anesthesiologist in the nation.

After a year in San Antonio, Dr. Arthur C. Scott hired Dr. Potter as anesthesiologist and the fourth staff physician for Temple Sanitarium, later known as Scott and White Hospital. She started at twenty-five dollars a week, plus room and board in the nursing students' dormitory.

But her hiring was conditional on approval by Dr. Scott's partner, Dr. Raleigh R. White Jr., who was out of town. Upon learning about Dr. Potter's appointment, Dr. White wrote Dr. Scott. "I will be home soon, for I know you have lost your mind if you have employed a woman doctor." Once home, he authorized a one-month probation.

"So far as I know this probation lasted until July 31, 1947," Dr. Potter quipped upon her retirement forty-one years later.

Dr. Claudia Potter, Texas' first woman anesthesiologist and the first female anesthesiologist in the United States, practiced at Scott and White Hospital in Temple, Texas. *Courtesy of Scott and White Hospital.*

Her early duties included hauling patients on stretchers, sharpening scalpels and pulling "private duty" nursing tasks for the ill—all after a full day in surgery in the hospital and away.

"I had a burning ambition to make good in my work…unlimited energy and I loved humanity and men (in the plural) in particular," she said.

When a medical school classmate came courting in Temple, Dr. White gave her a $300 a year raise to try to discourage "any serious business."

Dr. Potter, who remained single, lived in Temple and tended people in rural communities up and down the Santa Fe track. "One cold February morn about 10 a.m. Doctor White and I left Temple in a two-horse buggy…for Lott, Texas. The buggy wheels cut through the mud and ice half hub deep in places."

They would operate in the kitchen. "I then took my mask and ether…took the child to dreamland," she said.

Motorcars replaced the horse and buggy, and Dr. Potter bought a roadster, a Hupmobile, in 1909.

At another emergency call, an appendectomy took place on a makeshift table in a field near Rogers one hot July day. She administered the ether.

Another occasion, near Gatesville, "the only possible place (to operate) was in the room…at least 10–12 feet from the open fire…I had large wet towels on the table beside the patient's head, ready…I expected a flame to come up from the pillow any minute."

Sensitive to her patients who now no longer had to endure surgery without anesthetics, she sought to relieve the vomiting afterward. Dr. Potter continued studies at John Hopkins University School of Medicine and the Mayo Clinic as advances in anesthesia were made.

A doctor's buggy. Dr. Claudia Potter plied her trade as anesthesiologist up and down the corridor of towns served by the Santa Fe Railroad, when she began at Scott and White hospital. She drove a buggy before cars took over. Before she retired, she thrilled at the sight from the belly of an airplane.

By 1929, aviation had arrived. She described her first flight to Coryell County. "We put the surgical bag on one wing, strapping it on; next, I got in on my stomach on the stretcher and they shut the top of the plane down over me. I could neither turn over or raise up but could hang my head out at the side and look down at the earth as we were flying over it."

Returning at night, she said, "I will never forget the thrill…looking down…one by one the lights came on in the little country homes…car lights began to show up on the Waco highway…reminded you of light posts on a city street. I felt God had let me live in a wonderful age of progress."

Confronted with the danger of landing at night without lights, she said, "If we land safely, I wouldn't take a million dollars for the trip, and if I die, I die happy." But she did not tell her mother.

Years later, before Dr. Potter died on February 2, 1970, at eighty-nine, professional societies feted her, including the UT Medical Branch's "Golden T," an alumnae award to distinguished medical school graduates, awarded to her for her fifty years of service to medicine, the first woman so honored.

THE "FLYING SCHOOLGIRL"

Katherine Stinson

At seventeen, in 1910, Katherine Stinson knew no fear. She wrestled hand-cranked Model-Ts and their forerunners over the ruts of Arkansas' country roads. The Wright brothers had flown seven years before, and she wanted to do the same. Her mother, a passenger on her drives, agreed that she should. "My father," Katherine said, "he was like the hen with an unmanageable duckling in its brood." When both parents agreed, she "set out to be an aviator as a means to becoming a music teacher" to pay for studying in Europe. Barnstorming paid well.

The Stinson sisters. Katherine, right, the "flying school girl," held the fourth woman's pilot license in the United States. A barnstormer and mail carrier—both firsts for a woman—she flew for Asian and European audiences as well as in the United States, packing up her plane for shipment and then carefully reassembling the wings. The Japanese called her "The Air Queen." Katherine's younger sister, Marjorie, followed. She joined the family business, teaching World War I pilots at the family's Stinson Field in San Antonio. Marjorie's Canadian aviators called her "Texas' Flying School Marm." *Photo courtesy of San Diego Air & Space Museum.*

Katherine sought the most famous of a pack of flight instructors emerging since the Wright brothers flight, Max Lillie of Chicago, who declined to train her. At just five feet and 101 pounds, he judged her too small to manage the two shoulder-high sticks, the controls for his plane. Katherine begged. She finally persuaded Lillie to teach her for a cost of $500. Her family sold their piano to pay for lessons.

On July 12, 1912, four flight hours later, she became the fourth woman in America to earn a pilot's license. From then on, she would establish many firsts in the skies, not just for women. She barnstormed, dressed like other aviators in a coat, knee-high boots and a helmet that corralled her long curls. Flying, "nothing else like it," she said, replaced the music dream.

Katherine taught her brothers and sister to fly, and along with their mother, they established Stinson's Aviation Company and moved it to San Antonio in 1913, the first airfield west of the Mississippi. They built and maintained airplanes and ran a flight school. Katherine practiced at the field, teaching herself to fly the "loop to loop" stunt, the first woman to do so.

Before every air show, she tended her plane. "The men thought I was a regular old maid about it. They said I would ruin the cloth with my scrubbing, and that the oil didn't hurt the wires and joints, anyway," she said, "But I wanted to see the conditions of things under all that dirt." She found wires that needed replacing. "It's okay with an auto to have a breakdown," she said, "but if your airplane breaks down, you can't sit on a convenient cloud and tinker with that!"

Katherine flew night exhibitions, fireworks blazing on her plane's wingtips. She spelled out "Cal" with fireworks in California in 1915, becoming the first night skywriting pilot. For these shows, Katherine packed up her plane and shipped it across the country from Texas by rail in the United States and by boat for overseas events. She reassembled the plane at each destination.

In England, she buzzed Parliament. In 1916 in China, she provided a private show for the leaders and toured in Japan, the first woman to fly the Asian skies. Japanese women dubbed her "the Air Queen," and newspapers hailed her as the "world's greatest woman pilot."

Back home, she flew from Buffalo, New York, to Washington, D.C., dropping Red Cross leaflets and fundraising for World War I. Because she was a woman, the army turned her down. Instead, she set a world record for distance, flying 610 miles from San Diego to San Francisco, climbing to 9,000 feet, an altitude she had not flown before. The flight took nine hours and ten minutes. Two gallons of gas remained in her plane when, always a showman, she circled the Golden Gate before landing at the army's field.

"Tears came to my eyes as I heard the cheers of thousands of soldiers down below. They were lined up in two files and I landed between them," Katherine said.

Still the army refused to let her fly combat. She set two more records. Katherine hauled the U.S. mail, the first woman aviator to do so, and flew nonstop from Chicago to New York, a new distance record of 783 miles.

Before the flight, she had been sick for five days. "After all," she said, "you have to choose which is going to rule, your mind or your body…If you determine that it shall be your mind, your body will surprise you by the way it bucks up and behaves itself."

If she couldn't fly, Katherine determined to get into the war action in another way. She drove an ambulance in London and France, evacuating wounded soldiers from battle, and continued to badger the army to let her at least fly the mail across Germany, all to no avail.

She paid a price for her ambulance duty, however, contracting tuberculosis, which grounded her in 1920. Seeking a drier climate than San Antonio, she moved to New Mexico, married and lived there, often in poor health, until her death at eighty-six in 1977.

UT Prof Adds to Texas Lore and Science

Dr. Mary S. Young

The only girl among "a number of children," Mary Sophie Young scrapped to keep up with her brothers, which may have conditioned her for her outdoors and scientific pursuits in later years. Described as quiet, diminutive, shy and studious by her professors, she refuted all but the latter in the way she lived her life.

Teased by her brothers because she did not join them in the honor society Phi Beta Kappa, she rejoined, "Perhaps I would have, had my college [Wellesley College] had a chapter."

After graduation in 1895, Mary Sophie spent several years teaching in public and private schools in Missouri, Illinois and Wisconsin. She studied by correspondence at the University of Chicago in summers and attended some long terms at the campus.

In 1910, she earned her doctorate degree in botany and took a position at the University of Texas (at Austin), first as a botany tutor and the next year as an instructor.

She tramped the hills and fields—off the beaten path—around Austin, collecting specimens of the area's famous wildflowers. She carried a "collecting can, a thermos of water, and a light lunch," starting at dawn and returning late in the evening.

The bluebonnet became the state flower in 1901, blooming in most regions of the state, though perhaps most prolifically in the Hill Country. It was one of the species Dr. Sofie Young studied in her tramps through these hills outside Austin.

Often a student would accompany her. Often she offered room and board to students, who struggled financially to stay in school, preferring boys. Often she loaned money at no interest, with the words, "pay when you can."

And always, in the classroom, she answered questions with more questions, stimulating and challenging students "to think on their own."

Because of her "impeccable works of scholarship," the university also put her in charge of its collection. She was charged with identifying and classifying species of plants and putting together a "complete representation of the local flora," a system called taxonomy, for the university's herbarium, the building housing the collection.

Professionally, Mary signed her writings Dr. M.S. Young and enjoyed the confusion when others wrote, mistaking her for a man. Perhaps she believed this would improve the reception of her body of work

But soon, the West called. In the summer of 1914, Dr. M.S. Young discovered new challenges in the mountains of Texas' Trans Pecos—botanical and personal challenges.

Dressed in her usual high button shoes, long skirt, long-sleeved high-neck blouse and a big brimmed hat, she and a student took the train for Marfa. Once there, she outfitted them with a pair of burros and an aged but roofless carriage to carry their supplies into the Davis Mountains. She hid a .25-caliber Colt automatic in her skirt pocket and packed a .22-caliber six-shooter revolver. Skilled with these, she brought down jackrabbits, which she learned were so tough that she made a shoe heel out of the meat of one.

Describing her first experience with burros, the Episcopal minister's daughter wrote of her burro that had "the traditional cross on his back…If our Lord rode as lazy a beast as this one, the triumphal entry into Jerusalem must have taken a long, long time."

She and her teenage companion camped at an abandoned adobe house. "It has been long uninhabited…dirty inside, but we found the gallery a much better place to sleep than the ground.

"We had a campfire and sat by it until about ten o'clock…in front of the house is a lot of *Aloysia Ligustrina* (verbena) in full bloom and very fragrant…we left our dishes by the campfire and a hog came along and washed them for us. I see dents in one of the pans made there by either the teeth or feet of the hog."

The next day she washed dishes, "the first time since we left Austin. We have used newspapers before. It was that hog…I would as soon eat after a horse, but I refuse to eat after a hog," she wrote.

On her treks in the Davis Mountains, Dr. Young found wild orchids, ate huge peaches, got lost, rousted a black bear and stoned a rattlesnake to death for his rattles.

For the next four summers, she returned to the Davis and Chisos Mountains, collecting species of plants for her university's collections and chronicling the plant lore of Texas.

In 1919, Mary entered the hospital for a minor operation. After the surgeon stitched her up, he revealed that he had discovered advanced cancer tumors. She died soon after. Her stoicism in the face of the disease—"she didn't want to burden her friends"—furthered the esteem of friends and colleagues. Respected for her work and admired for her many contrasts—petite but tough, shy but generous, a bookworm but humorous—students, colleagues and even her dog, named Santa Claus, mourned Dr. M.S. (Mary) Young.

Chapter 8

ENTERTAINMENT, CULTURE AND SPORTS

C ontinuing the march toward settling Texas, women—some of whom had been spies for armies—arrived to bring culture or to entertain. Others born here craved to practice their art, be it in hotels or mansions, in church halls or on European stages, while yet another native daughter challenged the sports world. Most drew acclaim, at home or abroad, and all were a lively bunch of Dames, unique in talents and scattered across the landscape of Texas.

"A Texas Show for Texas People"

Mollie Bailey

Expected to be a genteel southern lady, Mollie Kirkland seemed to have other ideas from the time she could walk and talk on the plantation where she was born about 1844 near Mobile, Alabama.

She put on shows where she starred, mimicking servants, family members and visitors in the way they walked and talked. Then she would become all business and shadow her father, learning how he managed the enterprise.

He sent her to boarding school at twelve, where she was described as "gypsy-like in appearance, dark hair, flashing black eyes, and a vivacious manner…"

On a vacation at home, Mollie shucked her tomboy ways. She met a boy, the bandleader in his father's circus. When her father would not let her marry Gus Bailey, Mollie ran off. They eloped, and she joined him in his father's circus. Twice she went home to seek her father's forgiveness. Twice he refused. He disinherited her.

One night, however, she appropriated a bit of that inheritance, sneaking onto the plantation to "borrow" horses and two wagons. Mollie had convinced Gus

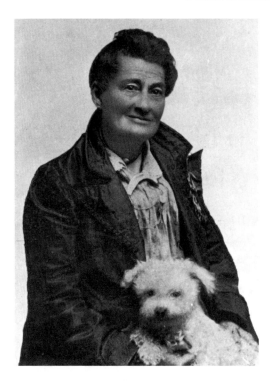

Mollie Bailey, lured into dramatics by her boyfriend's family, used her showmanship talents as a spy for the Confederates during the Civil War. *Courtesy of Western History Collections, University of Oklahoma Libraries, Rose 447.*

to start their own circus, even though they were broke and had no equipment. They formed the Bailey Family Troupe, a vaudeville show with Mollie starring as leading lady, soloist and organist, and played throughout the south, yet both of them yearned to come to Texas.

The Civil War intervened with their Texas plans but added to Mollie's reputation. She parked her first-born daughter with a friend and joined Hood's Minstrels, entertaining the Texas brigade with song and dance. When soldiers from Arkansas needed quinine, Mollie tucked packages of the medicine into her pompadour, delivered the quinine and returned safely. An officer said, "Depend on a woman to think up a good scheme."

On her next spy mission, the teenage Mollie made herself up to look like an old woman and mimicked the stooped stance of an elder. She crept about the Union camp selling cookies and collecting information for the Confederates.

After the war, broke again and now with three daughters, Mollie and Gus joined a dramatic company that she called "a boat show" until they formed the Bailey Concert Company.

It took until 1879 for Mollie, Gus and their nine children—some grown and working with the show—to realize their dream of moving to Texas, traveling the state. They bought a winter home in Dallas in 1885.

Each spring, they went on the road until December, taking the Bailey Circus, which they described as "A Texas Show for Texas People," to small towns and rural areas. First stop were the sawmill towns of East Texas, then to South Texas, back through Dallas, and out to the Panhandle and West Texas.

The show, the "Mollie Bailey Show," would roll into town early in the morning with mule-drawn, brightly colored wagons. Mollie, in the lead, bowed to all who gathered. The red uniformed brass band marched behind. A daughter and her pet bird act followed, the daughter riding a large black horse with a riding skirt tickling the horse's fetlocks. A son and his trained canines came next, then another son's "educated ponies" and, lastly, the clowns and animals. Quite an entry.

For health reasons, Gus had to retire to Blum, but Mollie continued to travel, staying in touch with him as communications changed—first by mail, then telegram and finally telephone.

She bought town sites where they played rather than pay the steep rent and then would let the communities use the sites for ball fields and camp meetings between her annual visits. Confederate veterans flocked to their former spy's circus and planned Old Soldier reunions to coincide with the "Mollie Bailey Show." She gave free tickets to veterans from both Confederate and Union armies and let poor kids get in free.

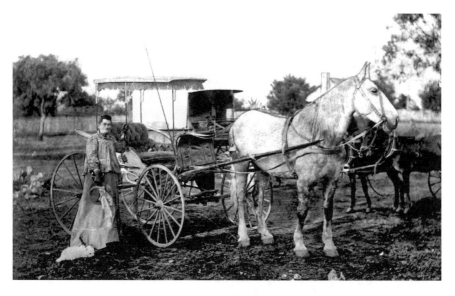

After the Civil War, Mollie Bailey, her husband and children went "over the road," taking the circus to rural Texas areas. She traveled in her decorated buggy, carrying her black purse, which was her bank. *Courtesy of Western History Collections, University of Oklahoma Libraries, Rose 450.*

Mollie managed the logistics of the 200-plus-piece circus and carried a large purse, her bank, to pay cash for the show's expenses.

A savvy businesswoman, she changed with the times. When she moved her circus by train, she entertained in her parlor car, hosting governors, senators and members of Hood's Brigade, her Civil War unit. She set up a separate circus tent and added movies. Some say she was the first to show a movie in Texas, a one-reel film about the sinking of the USS *Maine*.

Gus died in 1896, yet Mollie continued. One fellow in Coolidge said, "She is everything a show should be—clean, wholesome, no skin games. She's… well, she's Mollie Bailey and I'm going to her show as long as she comes over the road."

Texas' first woman circus entrepreneur ceased coming "over the road" in 1918, when she died in Houston from complications of a broken hip. Soon after, the Mollie Bailey Show ceased.

"A WORK OF HIGH ORDER"

Elisabet Ney

Elisabet Ney arrived in Texas in her forties as an accomplished sculptor with a life spiced with kings, queens and the adventure of spying. The intrigue probably sent her and her husband—although she referred to him as "Best Friend"—fleeing Germany to Georgia, where she shocked and stirred the gossips. She refused to acknowledge her civil wedding and retained her maiden name, even as two sons came along, an affront to the post–Civil War Georgia of 1871.

She would offend these same sensibilities in Texas the next year. In Waller County, she found an old Texas colonial's plantation, Liendo, and convinced her best friend, a doctor and scientist, to buy it. "Here will I live and here I will die," she said.

For the next twenty years, she put aside her sculpting career to run the cotton farm.

Her sculpting had begun at her father's knee before gaining admission to Munich's Academy of Fine Arts as the first woman sculptor when she was nineteen, in 1852.

But in 1872, in Waller County, she ran the cotton plantation, despite knowing nothing of farming or business. She oversaw the free blacks but rankled them, much as she did her neighbors. They thought her odd. She thought them backward. She rode into the fields astride, wore pants and Grecian robes, her auburn hair tucked up tight. Meanwhile, her best friend researched and wrote.

He also left their sons to her until one died from diphtheria and the other she dressed in Grecian robes and sent to town. Teased by others, he remained estranged from Elisabet the rest of her life.

Yet in this time, she had begun to meet Texas' elite, much like in Europe where she sculpted for philosopher Arthur Schopenhauer, composer Richard Wagner, King George V, Ludwig II and Italian soldier Garibaldi. As a small child, Elisabet had set a goal "to know great persons."

Governor Oran Roberts visited Liendo Plantation, knowing of her work, and asked her to meet in Austin about statues for the new capitol building. Although that commission did not pan out, it returned Elisabet to her art and brought her recognition as one of Texas' first sculptors.

A women's group did commission her to create likenesses of Texas' heroes for the Chicago Centennial of 1893, Elisabet's sixtieth year. She built a studio in Austin. There, in time for the 1893 Chicago Fair, she completed Sam Houston's buckskin-clad figure in plaster and accompanied the replica to the Texas exhibit.

That sculpture showed off her talent. Texas political leaders and prominent Austin women commissioned works from her. Elizabet molded statues of Houston and Stephen F. Austin for the capitol in Washington, D.C., and also for the entrance to the state capitol's rotunda. In the same year, 1903, she completed the memorial statue of Albert Sidney Johnston for the Texas State Cemetery.

A peer called this statue "a work of high order" and noted that Elisabet was one of the "best equipped" women sculptors. In Europe, she had been known as "the most competent and gifted woman portrait sculptor in Germany."

She had set her artistic trajectory in her teens when she rejected her mother's housewife role and sought formal training. When she believed she had learned all she could from her father, she demanded schooling. Her parents balked, so she staged a hunger strike. They relented but insisted she wait two years.

Elisabet lived differently, continuing to be a stranger to the kitchen. Calling her Austin studio and home Formosa, she worked and entertained there with tea and cheese or clabber, sour milk that has curdled. She found a niche that "constituted the nucleus containing all in all that makes life dear to me."

Her best friend stayed on the plantation, researching and writing and visiting Austin by train. She stayed at Formosa, sculpting and entertaining, and visited Liendo, driving her gig and stopping at farms overnight, where she hung her hammock between trees.

She taught one female sculptor and then passed on her work and her beloved Formosa to artisans and admirers at her death. On June 29, 1907, Elisabet Ney made her last trip to Liendo to be buried, four years before her best friend, Dr. Edmund Montgomery, would follow.

Her patrons formed the Texas Fine Arts Association in 1911 in her honor, and Formosa housed her collection, which she wished to be a part of her adopted University of Texas. Today, it's the Elisabet Ney Museum in Austin.

Teacher, Author and Folklorist, She Stirred the Winds

Dorothy Scarborough

The youngest in a family of writers, Dorothy Scarborough bent traditions and staked a claim as a preeminent regional author. Born in 1878 in the tree-thick country of Mount Carmel near Tyler and then transplanted to the windswept plains of Sweetwater, the land—particularly the wind—inspired her.

While Dorothy's family only lived in Sweetwater for four years, the wind—hot or cold—made a lasting impression. They had moved west for her mother's health, and then from there to Waco so the Scarborough children could attend Baylor University.

From their home that later became part of Baylor's campus, Dorothy would climb an oak tree in the yard and nestle in the branches to read and write, scribbling stories for her family. "I always wanted to write," she said of that time, and shortly before her death, she still claimed, "Why, I have books I must write that will take me more than a lifetime!"

She grew up on the campus, earned her bachelor's degree there at eighteen and her master's at nineteen, in 1897, and then taught creative writing from 1897 until 1916. She studied at the University of Chicago in summers and in 1910, when England's Oxford University first allowed women to study (but not earn a degree), Dorothy studied literature there.

Returning to Baylor the next year, she taught the first journalism course in Texas and the South, using it as an outlet for her creative writing students. While she studied abroad, the Texas Folklore Society was born, and when Dorothy returned, she joined and served as president in 1914–15. That year she presented "Negro Ballads and Reels" as her presidential address, telling of the songs she heard and came to love while a child accompanying her father to inspect the cotton fields.

The itch to write and the zeal to earn her doctorate continued. After her parents died, Dorothy moved to New York at the age of thirty-eight. She received her Ph.D. from Columbia in 1917, and Columbia appointed her to teach creative writing. Her first novel, *In the Land of Cotton*, based on her research into the Texas sharecropping system that she had witnessed, came out in 1923. The Texas governor hosted her, and Baylor awarded her an honorary doctorate.

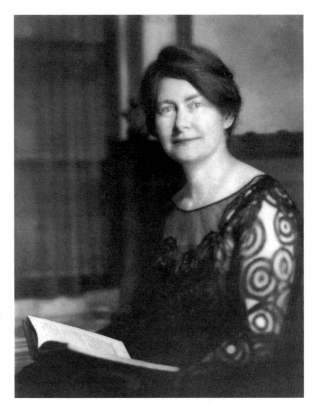

Dorothy Scarborough wrote, published, alienated West Texans and started journalism classes at Baylor University in Waco. *Photograph Courtesy of the Texas Collection, Baylor University.*

Teaching by day and rubbing elbows with the publishing world down the street in New York kept Dorothy—or "Dot" or "Miss Dottie," as friends called her—away from Texas. But she claimed she was "first a Texan…second a southerner." Miss Dottie gathered students and writers and homesick Texans for "at homes," gatherings of Texans at her home in New York, while she taught and wrote. She also continued her Baptist faith. "In New York you need your religion more than you ever did before," she said

She watered her roots by gathering with Texans and writing folktales, songs, novels, poems and stories about Texas and its cowboys, Mexicans, blacks and women.

In 1925, Dorothy hit her stride. Three books were published: *On the Trail of Negro Folksong*, where she expanded her earlier folklore presentation; *The Unfair Sex*, a novel that tracked her experiences at Oxford; and her most popular, *The Wind*, a novel set in Sweetwater. Dot's portrayal of the West Texas town was not favorable. She described the climate and the frontier in harsh and unsettling terms, a departure from the "Texas mystique" of other Texas writers.

Her book angered the citizens of Sweetwater, but when she visited, she won them over. One who knew her described Dorothy as "our demure, delicate, poised, other-minded Dot."

During the furor *The Wind* stirred in Texas, Dorothy said it "has its real origins in the impressions I got from hearing my mother's vivid accounts of her struggles with the climate of the West. She loved the people out there, but she did not care for the weather…"

Those impressions stuck. Over lunch in Texas with visiting author Edna Ferber, who complained of being "nervous," Dorothy said, "It's probably the wind," and then she launched into a description of her plan to write a novel about the wind. Two years after the book was published, Hollywood produced it as a silent movie.

Dorothy wrote several novels and books, but none as successful as *The Wind*. More were in the planning stage, and one was on the press the night Miss Dottie died in her sleep at fifty-seven. From a short memorial service in New York, she was returned to her native state for burial in Waco in 1935.

BONHAM MUSICIANS BACK FUTURE OPERA STAR

Roberta Dodd

A young girl who would break into song at any minute while she waited tables at the Curtis Boarding House or spin a few cartwheels on the lawn where she cleaned house caught the ear of Bonham musicians. Born in 1897 in Tank Town, the black community, Roberta sang while she worked at the Curtis Boarding House in 1914.

A musically rich community, Bonham enjoyed the cultural benefits of a college town, sustaining two opera houses through the first quarter of the twentieth century and attracting voice and piano professors and instructors. It did not take long for these professors, in-home teachers and church choral directors to book Roberta Dodd into their churches and social functions and introduce her to the Alexander Hotel, where she became a hit.

First Christian Church, with its magnificent pipe organ for accompaniment, and First Methodist Church vied for Roberta's talents. What critics described as her "clear tones" pierced the existing boundaries of segregation of East Texas in the 1900s. Not only did the Bonham women hear and enjoy Roberta's voice, they banded together, with other community leaders, to send the girl from Tank Town to Wiley College in Marshall, the first step in her formal education.

Next came Fisk University in Washington, D.C., and then the University of Chicago, where she studied under Madame Herman Devries and where she met

World War I officer Captain Crawford. She married him between her studies with voice teacher Madame Devries and concerts in the opera halls of major American cities. Chicago critics wrote glowing reviews. One wrote, "This young colored soprano is gifted with a voice of individual quality and great beauty…it is the purest at its glistening top…Mrs. Crawford [Roberta] has a control in her upper register that is marvelous and the pianissimo quality is exquisite." Roberta went on to give concerts in the opera halls of major American cities.

"Her French is beautifully pure and her diction in all languages is good," wrote another critic. "She is most gracious to meet with a silvery and a softly melodious speaking voice and a well-born courtesy and earnestness," wrote another. Most called her voice "bell like in quality." She had a "facile mastery of vocal technique, ample musicianship, and a delightful artistry of presentation."

Singing in five languages, the cartwheel turning teenager returned to Bonham in 1928 as a sophisticated contralto soprano for a performance in First Methodist Church. Roberta's family, her benefactors and the townspeople came to hear the little gal from Tank Town all grown up. Roberta's family and her friends from the black community sat in the balcony while white patrons filled the downstairs, in accordance with the segregation of the 1920s.

She entertained with an evening of songs in four languages—French, German, Spanish and English. In the '20s, few opera stars sang in Spanish, but Roberta had studied under a Spanish opera singer while at Fisk. "She sings these songs with beautiful diction and in excellent Spanish style," wrote a Bonham reviewer after Roberta's homecoming performance.

The standing-room-only concert in First Methodist Church would be her last one at home before making her European operatic debut in Paris, France. On this, her last night home for the next twenty years, Roberta sang not only arias but also Negro spirituals and "a primitive African melody."

Before her first note rang out in Paris, though, Roberta's husband was killed. Yet she still opened at the *Salle Gateau*, singing in five languages. Europe stages and concert halls became her home for the next twenty years, especially Paris. In 1932, she met and married a man from French West Africa, but he lived only a few years.

While Europeans crowded opera houses across the continent to hear the lovely black singer from Texas, Roberta supplemented her income working in the Paris Public Library. She was there when World War II broke out, and so she joined the Red Cross and sang in churches and canteens for American soldiers. Some say she was imprisoned in a concentration camp during the German occupation of France. Others say that's not so.

What is known is that Roberta Dodd Crawford returned to Bonham, Texas, three years after World War II, "poor in spirit and in health…unable to perform."

Roberta Dodd Crawford died in Dallas in 1954, young by today's standards, perhaps worn down by war and the vagabond nature of making a living with her bell-like voice. She was buried in Bonham, next door to Tank Town.

Greatest Athlete of the Year—Seven Times

Babe Didrikson Zaharias

A tomboy who once said, "I'd trade all my medals for a child," Mildred "Babe" Didrikson Zaharias hovered over her friends when they gave birth. One time, a call from President Dwight D. Eisenhower came into the room for Babe. "Tell him I'll call back," she said and continued helping the new mother and baby.

In three sports—basketball, track and golf—Babe broke ground for women athletes. The Associated Press named her the "Greatest Athlete of the Year" seven times.

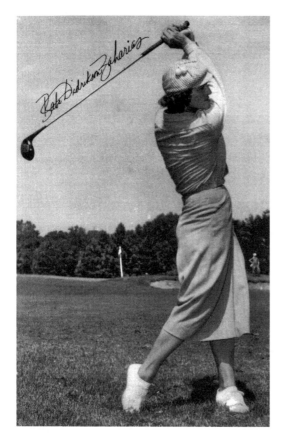

Babe Zaharias Didrikson took on all comers in women's sports before concentrating on the one she's most remembered for—golf. Speedy, cocky, compassionate, competitive and determined, the youngster from Port Arthur and Beaumont led in women's basketball, then track, where she garnered Olympic fame, before the links drew her. *Courtesy of the Babe Didrikson Zaharias Foundation.*

The Port Arthur native grew up in Beaumont running, racing a sister and leaping neighbors' hedgerows. She raced the streetcar. She smeared grease on the tracks of the streetcar before she raced it. She walloped the schoolyard bully. The only fights she ducked were when a parent tried to catch her for a spanking. She ran away with the circus with her sister. Her father found them in California doing headstands on elephants and noted that Babe "was late entering the sixth grade."

Entering Beaumont High School, she started on the girls' basketball team as a freshman forward. In her senior year, a scout proposed that she clerk for his firm and play for the company team. By the end of dinner, the Didriksons agreed. Babe left school for Dallas to start for the Golden Cyclones. She led the scoring and, in 1930, earned her first All-American title, an honor repeated the next year.

However, the 1928 Olympics—the first year women could compete in track and field—had caught her eye. She nailed a slot in the next Olympics, on the 1932 U.S. team. On the trip from the Chicago trials to the Los Angeles Olympic village, while teammates "played cards, watched the scenery, or gabbed, I kept up my training," using the train's aisles. She won two gold medals and one silver that year.

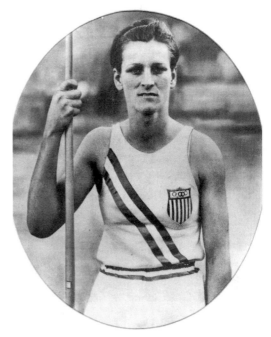

After the games, she unwound on the links with borrowed clubs. But once back at the insurance company, she chafed, restless without the acclaim and the competition, though she needed to work. She tried entertainment— singing, playing the harmonica and giving sports demonstrations—but did not like it.

Taking her parents with her, she returned to California for golf lessons. The pro taught her for free until she had to return to Dallas for work. As a backer, the insurance company sent her for lessons. She would

Babe Didrikson Zaharias at the Olympics in Los Angeles, after which she played some golf. *Courtesy of the Babe Didrikson Zaharias Foundation.*

go for an hour before work. At lunch, she practiced putting and chipping in the president's office, and at 3:30 each afternoon, she hit the practice tees "until my hands bled…I taped them and they'd bleed." Babe boomed her tee shots 250 to 280 yards.

At night, she studied the rulebook. At a tournament when she disqualified herself for finishing play with a different ball, she said, "Nobody else would have known the difference if I'd kept quiet, but I'd have known. You have to play by the rules of golf, just as you have to live by the rules of life."

In 1935, she won the Texas State Women's Championship and soon after was declared a professional, a tag she fought since there were so few women's professional golf tournaments.

At an exhibition match, she met wrestler George Zaharias in January 1938 and took him home to meet her mother. At year's end, they married.

After Babe's amateur status was reinstated in 1943, she won seventeen amateur tournaments, including the Women's National (and USGA) Amateur held in 1946 and the Women's British Amateur in 1947.

Then she turned pro again, this time her choice, and won thirty-five more tournaments. Her fame and accomplishments provided a boost to the fledgling Ladies Professional Golf Association in 1948.

In 1953, her hometown honored her with a tournament bearing her name. That same year, doctors diagnosed her with cancer. She rebounded. "There was

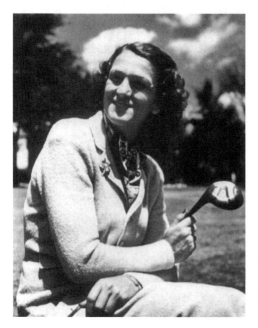

"The Babe" battled cancer but continued to compete in golf, raising money for cancer programs. "I want to help crush cancer into the earth," she said, before the disease claimed her in 1956. *Courtesy of the Babe Didrikson Zaharias Foundation.*

no doubt about my coming back again. With the love and support of the many friends I have made, how could I miss? Winning always has meant much to me, but winning friends has meant the most," she said.

This was the same woman who would enter a locker room and announce, "The Babe is here. Have you figured out who will come in second?"

Now she played to raise money for cancer programs. "I want to help crush cancer into the earth," she said. Her cancer returned in 1955. President Eisenhower sent a telegram this time, saying, "…the whole country unites in admiration of your courage. You have been an inspiration to all Americans."

Mildred "Babe" Didrikson's marriage to George had been rough because of his drinking, his physical abuse and his jealousy, yet she stayed. She had wanted children, but he had said no to adoption. Her last words to him, though, were, "I'll be going now, honey, thank you for everything." She slipped into a semi-coma and died September 27, 1956.

Chapter 9

REFORMING TEXAS AND TEXANS

In the years after the Civil War, when the state was knitting together its economy and political structure, women forged ahead to make the state a more fair place, especially to women, children and minorities. The tolerance for abuse subsided because of the efforts of some. Citing drinking as the cause of much of the abuse, quite a few lined up for prohibition. But most seemed to know that it would take parity at the polls to weave the reforms into the fabric of life for Texas and Texans.

SHE FOUNDED THE FIRST WOMEN'S SHELTER

Martha White McWhirter

In Belton, Martha White McWhirter established what has been known as Texas' first shelter for battered women and recognized as the United States' first successful commune. Begun soon after the Civil War, she called her group of women Christians. Detractors called them "sanctificationists." But in later years, the group gained respect as Belton Woman's Commonwealth.

It all began in grief. Martha was vexed. In 1866, she had buried two more children. This made six of her twelve children that had died young. Her brother also died that year. On an August day, she sat through a long, hot revival with no solace, convinced she must be being punished.

Instead, she heard a voice in her head. While doing dishes the next day, she spoke in tongues, a more common act then, even for her Methodist faith. She believed the experience to be one of sanctification, the removal of her sins by the Holy Spirit.

Martha McWhirter established a haven, believed to be the first, for women abused by men who drank too much when they returned from the Civil War. *Photo courtesy of UTSA Libraries Special Collections from the Institute of Texan Cultures.*

So Martha studied the Pauline gospels and the teachings of John Wesley and taught sanctification to her class at the Union Sunday School, the religious center in Belton in the early years. She also carried these teachings and the belief that God would reveal his will through visions, dreams and messages to her weekday prayer group of seven prominent women.

And so it began. Martha believed these women were "what God intended her to work with."

She was thirty-nine, had been a resident of Texas since 1855 and had been baptized a Methodist in Tennessee at sixteen. She and George moved from the farm into Belton in 1860, becoming leading citizens.

Her prayer group shared their sorrow over the "frequency that their men would become drunk and overbearing." One fled with her child to Martha's house after a particularly brutalizing night and stayed. Gradually, the McWhirter home filled with women and their children seeking safety. Those not abused were tired of begging their husbands for money for food and household expenses and feeling bowed and humiliated that they were not able to own property, even what they had originally brought to the marriage.

Martha unveiled a plan: to build a common fund with which to help one another. They sold butter and eggs and milk. When "a sister" was denied funds at home for a legitimate need, she could draw from the common fund.

A neighbor's complaint got their attention. Since the freed slaves had moved away, there were no laundresses. Martha and her sisters prayed. Believing

the humility of doing laundry would be good for them and would fatten the common fund, the women did the laundry, shocking the townspeople.

Because of this fund, when one member's husband "gashed" her head yet he filed charges against his victim, the common fund could pay her $100 fine. However, Belton residents seared Martha for supporting women to leave their husbands.

Over the years, she built homes for women on McWhirter land. When George objected, she reminded him of her property brought to the marriage. Their daughter and grandchildren moved in in 1879. George moved out, saying it was too crowded. He respected Martha but disagreed with her activities. They lived separately until his death in 1887, when she received her half of his estate and administered the children's half.

But from the women's work as servants, the butter and egg money and the properties bought and built with inheritances, her women's community prospered. The commune built the Central Hotel in Belton in 1886, which became a prime tourist stop, with each woman working and rotating tasks, making decisions by consensus. It acquired two hotels in Waco and bought a farm to produce food for the hotels. The community of thirty-two women thrived because of Martha's leadership and financial acumen.

With the hotel's success, her reputation improved. Businessmen elected her the first woman to Belton's Board of Trade, forerunner to the chamber of commerce. Her name is etched on the cornerstone of the Opera House. She contributed $500 to the town's effort to land a railroad. In addition, her community opened a room in the hotel to house the first library, organized by other women.

In 1899, growing older and restless in Belton, the Belton Woman's Commonwealth sold or leased its buildings and moved to Washington, D.C., where it bought a house and a farm in Maryland, paying cash, a principle of Martha's.

On April 21, 1904, Martha White McWhirter, age seventy-seven, died at the communal farm in Maryland. A tribute to her read "Belief with her is action… At the same time, she is a mystic, trusting implicitly in the revelations that come to her and to them all."

The Belton Woman's Commonwealth continued until the death of all the original members.

SOCIALITE EXERCISED CLOUT FOR WOMEN AND CHILDREN

Eleanor Brackenridge

Mary Eleanor Brackenridge never married, yet she fought for the rights of married women and children. She supported prohibition, believing it would help women and children who were abused and impoverished by drunken husbands and fathers. She tried to improve the rights of married women to conduct business and own property, and she stumped for women's right to vote. Eleanor used her position as a socialite to bring about evolutionary social changes.

Born and educated in Indiana, in 1855 she joined her parents and brothers at Texana (a steamboat port on Lavaca Bay), one of Texas' earliest towns. She arrived at eighteen, a graduate of Anderson Female Seminary, at the Brackenridge Plantation where her family had moved two years earlier.

Her brothers took different sides in the Civil War, and her father died midway through the war. Eleanor and her mother held onto the Brackenridge land until 1866, when they moved in with her oldest brother in San Antonio.

In the Reconstruction era in San Antonio, the brother that had supported the Union thrived. He appointed Eleanor as director of two of his businesses, San Antonio National Bank and San Antonio Loan and Trust Company, making her one of the first female bank directors in the nation.

She also traveled, participated in the Presbyterian Church and the Order of the Eastern Star and supported the Women's Christian Temperance Union (WCTU), nationally and at home. That involvement suggests a coalition with the state WCTU president, a Denton minister's wife, not only for the cause of prohibition but also to address other issues.

Leading the organization of women's clubs and founding "the first Texas women's club with separate departments (smaller groups with differing interests) in 1898" in San Antonio, Eleanor next instigated the formation of hundreds of clubs around the state, probably a result of a decade of WCTU involvement.

Yet these groups could do more. "Women's clubs are no longer amusing; they are the solemn rising of the good women of the land who organize to stand together as a unit to work for high purposes. And with them to aid and bless and encourage, are all good men," she said.

These "high purposes" included the need for police matrons at the city jail, for female probation officers, for industrial and vocational education in the public schools and bettering the "general welfare of women and children." As

such, even though she had no children, she helped found the Texas Congress of Mothers, later renamed the PTA.

In 1902, with encouragement from her brother and after seasons of petitioning the state legislature, she and a group of women won the battle for a college for women, the College of Industrial Arts, now Texas Women's University in Denton. Eleanor and two other women were appointed to the first board of regents, the first female regents of a Texas college. Classes began in 1903 with 186 students and fourteen faculty.

Establishment of the college required more activism. Funding the women's college became a calling, as did "chiding its members [legislators] for failing to vote for requested appropriations." Eleanor served as regent from the first year of the college's existence until her death in 1924. A residence hall bears her name today.

Her lobbying and chiding legislators to fund the College of Industrial Arts resulted in a familiarity with state laws affecting women. Eleanor's study became "The Legal Status of Texas Women," published in 1911, which influenced legislation regarding the property rights of married women.

In order to further these changes, Eleanor realized that women needed to be able to vote. So, the next year she resuscitated Texas' suffrage movement, which had languished since 1904. In 1913, she convened a statewide meeting of women's club presidents and suffragists from earlier years. She invited them to San Antonio "during our 'Battle of the Flowers Parade,' when the rates would be lower." The revived Texas Woman Suffrage Association elected her president.

At seventy-six, Eleanor presided for a year and then campaigned until 1918, when Texas and five other states led the nation for women's right to vote. That year, Eleanor registered to vote, the first woman in San Antonio. Joining her in signing up for their first vote were 386,000 Texas women. The United States' Nineteenth Constitutional Amendment passed August 26, 1920.

Of her activism, Eleanor said, "Foolish modesty lags behind while brazen impudence goes forth and eats the pudding."

For her obituary, the Valentine's Day, 1924 edition of the *San Antonio Express* wrote that Eleanor Brackenridge was "in many respects the foremost woman citizen of Texas."

She Brought Down a Governor and Ushered Women into Politics

Minnie Fisher Cunningham

Minnie Fisher, born on Fisher Farms near New Waverly in 1882, tasted the wine of politics early. Her father, a pre–Civil War state representative, took her to Huntsville for political meetings when she was a child. On the ride home "through the piney woods," they talked politics.

Yet politics would not be the first vocation for the home-schooled planter's daughter. At sixteen, she passed the state examination to be a teacher and then taught for a year.

Next came the University of Texas Medical Branch at Galveston, where she earned a pharmacy degree in 1901, Texas' first woman to do so. She worked in Huntsville as a pharmacist for a year. But the unequal pay for a woman "made a suffragette out of me," she said.

The next year, she married Bill Cunningham and then campaigned for his winning bid as Walker County attorney, reawakening her yen for politics. In 1907, as his alcoholism worsened, Minnie increased her political activism and the couple moved to Galveston.

By 1910, she was elected president of the Galveston Equal Suffrage Association. She toured Texas, rallying women, and in 1915 was elected to the first of four one-year terms as president of the state organization, during which time she quadrupled the numbers of local suffragette auxiliaries.

Minnie moved to Austin in 1917 to open state suffragette headquarters, from which she spearheaded the Texas campaign. There she collaborated with those seeking to impeach Governor Jim Ferguson for embezzlement of funds.

By this time, nicknamed "Minnie Fish," she joined the fray to "break the power of corrupt politics in Texas" and to remove Ferguson, a dedicated opponent to women's suffrage.

"The men are tremendously grateful as well as not a little surprised at the effectiveness of our work," she wrote. "I believe we can get most anything we ask of them if we do win."

They did. After Ferguson's impeachment, Texas passed the women's right to vote in 1918, two years before the nation.

The national organization asked Minnie for help. She "pursued governors all over the west," she said, until women could vote in 1920. Turning the suffrage movement into the League of Women Voters, she led the new organization, too.

Future first lady Eleanor Roosevelt heard Minnie address the league the next year. Later, as First Lady, Mrs. Roosevelt said that Minnie Fish made her believe

Minnie Fisher Cunningham, Texas' first woman pharmacist, went on to lead the state and nation to establish laws so women could vote.
Photo Courtesy of Houston Metropolitan Research Center, Houston Public Library, Houston Press Collection RGD-0005-f 390.

"that you had no right to be a slacker as a citizen, you had no right not to take an active part in what was happening to your country as a whole."

In 1927, Minnie's husband died and she returned to Texas. Political bells rang, and she answered, becoming the first woman to seek the United States Senate. She ran on a platform that advocated prohibition, tariff reduction, tax reform, farm relief, flood control, cooperation with the League of Nations and opposition to the Ku Klux Klan.

Finishing fifth among six candidates in 1928, Minnie remained a liberal, supporting the populist agenda and working in agriculture at Texas A&M and then for the U.S. Department of Agriculture in public information, a Franklin D. Roosevelt appointee.

In 1944, when other Democrats would not challenge Governor Coke Stevenson in the primary, judging it a hopeless effort, Minnie said, "Well, I've decided to do it myself."

At sixty-two, she became the third woman to seek the governor's office. Her backers proved to be women, soldiers who couldn't vote if they hadn't paid their poll tax even though they were serving in a war away from home and pensioners whose checks Stevenson had cut for budget balancing.

Minnie came in second in a field of nine, but Stevenson needed to stay home from the national Democratic convention in Chicago to campaign against her instead of leading the anti-Roosevelt delegates.

"We scared him out of going to Chicago," Minnie said. "That means my campaign's a success."

Minnie Fisher Cunningham retired to Fisher Farms to raise cattle and pecans and uphold populist issues and candidates. To sustain a liberal voice in Texas, "Minnie Fish" offered to mortgage Fisher Farms for the establishment of the *Texas Observer* in 1954. However, it was not necessary. Ten years later, the teacher, pharmacist, suffragette and liberal candidate's voice was silenced. She died December 9, 1964, at the age of eighty-two and was buried in her hometown.

One writer said of her, "She looked like a wren, but behaved like a hawk."

STANDING UP FOR HER PEOPLE; STANDING DOWN THE TEXAS RANGERS

Jovita Idar

Growing up in her father's newspaper business, Jovita Idar took on the ideals he espoused in *La Crónica*. While the Rio Grande flowed between Laredo and its sister city, Nuevo Laredo, dividing the countries, political dissent and rebellion flowered in both towns.

This was the climate Jovita grew up in, surrounded by rebellion and the pursuit of fairness and economic opportunity for Mexican Americans. Her father waged the war for fairness with his editorials and news articles, and when she became a young woman, Jovita joined him.

Born in 1885 as one of eight children, she attended school at the Holding Institute, a Methodist school in Laredo, where she earned a teaching certificate in 1903. Teaching Mexican American children in border towns like Ojuelos riled her—no books; too few desks, pencils or paper; no heat in winter; and no support from the Anglo taxing authority.

Jovita determined she could be a more effective force for change as a writer than a teacher, so she returned to her father's weekly newspaper and wrote, decrying the injustice and discrimination. In 1910–11, she and her family wrote articles criticizing Hispanic–Anglo relations, featuring stories on educational and social discrimination against Mexican Americans and their worsening economic plight. She criticized the loss of Mexican culture with the diminished use of Spanish.

Then vigilantes hung a fourteen-year-old Mexican American youth. Arrested for murder and awaiting his fair trial, a Laredo mob kidnapped the boy from the

jail, hung him and then dragged his body behind a buggy through the streets of Laredo. Jovita's anger boiled over. The Idar family paper stepped up its petitions for fair play.

They supported revolutionary activities in Mexico, in Nuevo Laredo and beyond. The Idar paper took a bold step in this revolutionary year of 1911, calling for a convention of the *Orden Caballeros de Honor*, a fraternal order, to discuss the outrage.

Jovita took a still bolder step. She joined the lodge in the first Mexican Congress. Topics for discussion included education, labor, social justice and economic opportunity. She led women to speak out and participate at a political meeting. For many Mexican American women, this was their first to do so. This meeting of the fraternal order became the first attempt to organize a militant feminist cadre, the League of Mexican Women, with Jovita its first president and organizer.

The first task of the so-called militants was to provide education for poor children and for women. The new league collected food, clothing and school supplies for poor families and held study sessions so that women could become more educated, too.

Two years later, in 1913, with the echoes of gunfire throughout the days and nights ricocheting across the river, Jovita's mission to help flowed in a new direction, called on by a colleague in the league. Asked if she would work in Nuevo Laredo, she and others formed the equivalent of the American Red Cross, La Cruz Blanca. In the midst of battles, they pulled wounded Mexican Revolutionary soldiers off the battlefield to administer medical first aid. Jovita became a war nurse with the Mexican Revolutionary Army.

When she returned north of the Rio Grande, she joined the staff of another Laredo newspaper, *El Progresso*, which led to her fame along the border.

United States president Woodrow Wilson had sent troops to quell the Mexican unrest that spilled across the river into Laredo. Jovita protested that order with an editorial in *El Progresso*. Texas Rangers were sent to close the newspaper for the insult to the president.

Three Rangers approached the newspaper to shut it down. Jovita stood in the doorway and prevented them. She is known in history more for this single act than for her lifetime spent bettering the conditions of Texas' Mexican Americans. Later, the Rangers succeeded in closing the paper, and Jovita returned to *La Cronica*. She took it over when her father died in 1914 and continued her calls for fair play.

Three years later, at thirty-two, Jovita married and moved with her husband, Bartolo Juarez, to San Antonio, where she continued her activism. She started a free kindergarten, worked as an interpreter for Spanish-speaking patients in a

county hospital and edited *El Heraldo Christiano*, a publication of the Rio Grande conference of the Methodist Church.

Teacher, writer, poet, feminist, political activist and Methodist churchwoman, Jovita Idar Juarez strove to bring a better life to the people of Mexican descent in Texas, prompting women to speak out and get involved, pressing for equal opportunity and educating children of the poor, though she remained childless. She died in 1946 in San Antonio at sixty-one.

REGAINING THE VOTE—SIXTY-FOUR YEARS LATER

Arizona Fleming

Born in the crosshairs of change, Arizona Fleming grew up to support a cause that others feared would get them killed—restoring the right to vote, a right her father once exercised.

On a sultry August day in 1889, a little black girl was killed by crossfire while crossing the street in Richmond, Texas, on an errand for her mistress. Five-year-old Arizona's parents had kept her home and therefore alive when the Fort Bend County War broke out between Jay Bird Democrats and the Woodpeckers. The Woodpeckers, rooted in Civil War Reconstruction alliances with Negro officials, held the county courthouse. The Jay Bird Democrats marched on them, firing.

From late 1865 to that day in 1889, blacks in Texas had voted and held office. In Richmond, they outnumbered white voters six to one. But a group of angry young dandies with time and money to ruminate and drink formed the Jay Bird Democrats, known as the White Man's Union of Fort Bend County.

After the 1889 war, this group controlled the ballot. Negroes could no longer vote nor hold office. Growing up there, Arizona seemed not to question this convention. She finished school and then attended Guadalupe College in Seguin, operated by the Baptists, training teachers, ministers and leaders.

When she graduated, she worked as a bookkeeper for a Houston laundry. She stayed four years before returning home to Richmond, where she became the leading seamstress of the community during the Roaring Twenties.

In 1927, she and three others organized the Fort Bend Fraternal Undertaking Company in Richmond. She established her credit rating, and when others were going out of business during the Depression, she bought up her partners' shares in the funeral home.

She bought a house. Discreetly, Arizona also joined and supported (long-distance) the National Association of the Advancement of Colored People (NAACP). In 1950, Willie Melton, a nearby farmer and fellow member

approached her to help end the Negro's lockout at the ballot box in Fort Bend County.

Willie and Arizona consulted with lawyers in Dallas and Houston while still seeking amicable access to the ballot. The two of them circulated a petition, stating: "We…Negro citizens of Fort Bend County, Texas wish to participate in all elections…to be allowed to vote in the Primary…May, 1950." But the Jay Birds refused, and the Texas attorney general ruled against the petitioners.

Arizona and Willie dug into their bank accounts to finance a lawsuit. He took the east side of the county, and Arizona took the west, convincing individuals to attach their names to the legal petition. Most feared retaliation, even death. Most remembered or had heard the stories of the Jay Birds' violent history. Most, like Arizona, were in their sixties. One said, "I'm an old man, use my name, they can no longer hurt me." All but Arizona, were successful farmers who had joined the NAACP.

She and the farmer contributed most of the funds. She attended the trial in Houston. The federal district judge ruled in their favor on May 1, allowing them to vote in the primary and runoff elections.

Again Arizona took one side of the county and knocked on doors in towns and farmhouses to get out the vote, which turned out to be peaceable despite fears. But the Jay Birds appealed to the U.S. Fifth Circuit Court of Appeals. Arizona and the Kendleton area farmer mustered the money, raising what they could, contributing what they could not raise for that court date.

This time, the appeals court upheld the Jay Birds. Arizona could not believe the reversal nor understand the reasoning. Willie called a meeting—he was president, Arizona secretary—of the Fort Bend Civic Club, early in 1952. Over one hundred showed up, the most ever. Arizona pleaded with the group not to give up.

They did not. They held fundraisers and sent appeals letters. Arizona and the farmer made up the difference in funds needed and they appealed to the United States Supreme Court.

Arizona and her colleague—the "only Negroes"—attended the Supreme Court hearing on January 23, 1953. The court ruled, eight to one, May 4, 1953, that the Jay Birds had violated the Fifteenth Amendment that allowed black men to vote.

After three years and a considerable dent in her treasure, Arizona could vote, casting her first ballot at age sixty-nine. It's said that she died penniless at ninety-two in 1976. But before her death, she said, "I'd do it all over again."

Fort Bend's Independent School District has kept alive the memory of the bookkeeper, seamstress, undertaker and political activist by naming a school, Arizona Fleming Elementary School.

SHE BROUGHT DOWN "WHITE ONLY" SIGNS

Christia V. Daniels Adair

High expectations by her parents, in tandem with low expectations by society, forged one young woman's life role. Christia V. Daniels, born in 1893 in Victoria, grew up in Edna.

Her father, though uneducated, insisted that all his children participate in knowledgeable political discussions at the dinner table, a mandate Christia found boring. Her mother, also uneducated, required church participation, a lifetime practice Christia adopted.

Both parents insisted on education. Christia went as far as she could in the black schools in Edna before her parents sent her to the black high school in Austin around the age of sixteen. Graduation led her to Prairie View State Normal and Industrial College, now Prairie View A&M, in 1914.

After graduation, she taught, first in Edna at the elementary school she had attended and then in Vanderbilt, where she met Elbert Adair, a railroad man. They married in 1918 and moved to Kingsville. Because Elbert wanted her to stay home and not work, she had time and enthusiasm to volunteer.

First she organized a Sunday school for the children of the black church. Then she brought black and white women's organizations together to campaign

Christia V. Daniels Adair took on the injustice of segregation and discrimination in Houston, joining the NAACP and backing efforts for new, fairer laws and lawsuits. *Photo Courtesy of Houston Metropolitan Research Center, Houston Public Library Christia V. Adair Papers, MSS 0109-0037.*

for women's suffrage. When Texas women won that right in 1918, "we dressed up and went to vote," Christia said.

But the black women were turned away. "Blacks don't vote in the political party primary election in Texas," the official told her.

"That just hurt our hearts real bad," she said.

In time, Christia would help remedy this injustice, but not before a presidential insult to her "little black children." When President Warren G. Harding's whistle-stop tour roared into Kingsville, Christia brought her Sunday school children. Instead of shaking the hands of her front-row children, the president reached over their heads to touch the hands of white children.

"I pulled my children out, hurt, disappointed, and sorry for the children," Christia said.

These hurts and injustices fermented. She and Elbert moved to Houston in 1925, and Christia found a voice. She volunteered for the youthful National Association for the Advancement of Colored People (NAACP).

When a black man was found not guilty by a Houston jury and then killed on the courthouse steps, Christia's outrage catapulted her into a leadership role with the NAACP. After Elbert's death in 1943, she poured her life into the organization as its executive secretary.

The next year, twenty-six years after Texas white women got the vote, Christia voted, a result of the U.S. Supreme Court striking down Texas' laws preventing blacks from voting in the primary. The ruling came as the result of the NAACP lawsuit she helped instigate, along with Arizona and the farmer.

Angering some Houstonians, she was threatened often. She "shrugged off threats," said one friend in the NAACP.

With her leadership, many of the "white's only" signs came down: at Houston's airport, at Harris County government hiring venues, on city buses, on juries and on the Veteran's Hospital swimming pool and barbershop.

On the basis of the testimony of Christia and others, a grand jury ordered the police department to stop using "whipping posts," the practice of beating blacks who did not answer questions about the crimes for which they had been arrested.

Houston newspapers reformed. Blacks would no longer be referred to by first names but would carry the titles of Mr., Mrs. and Miss, like whites.

And then one day, "I bought a $27.50 girdle I did not need," the slim Christia said. She asked to try it on, a request that wound its way to the store manager. With some discussion, he agreed, and Christia had wrought a change in Houston retailing. Blacks could try on clothes before they bought them—in dressing rooms, like whites. Previously, blacks had to purchase clothes without trying them on; those stores that allowed blacks to do so required they use a separate dressing room.

Her determination to wring fair play out of a '40s and '50s society that took segregation and prejudice for granted wore her down. In 1959, she retired, saying, "I had reached the end of my capacity." She was sixty-six.

Yet after retirement, she became active in the Democratic Party and continued her father's maxim of being an informed participant. She also lived out her mother's teachings to be responsible to the church, chairing a committee of Houston's Boynton United Methodist Church and serving on the national board of missions.

She is one Texas Dame who lived long enough to see acclaim roll in. In 1974, the National Organization for Women (NOW) honored her suffrage activism of fifty-six years earlier. In 1984, when she was ninety-one, Harris County named a local park the "Christia V. Adair Park." The same year, she was inducted into the first Texas Women's Hall of Fame.

Five years later, at the age of ninety-six, Christia V. Daniels Adair died on New Years Eve.

TEXAS' FIRSTS

Female Officeholders

The years between 1910 and 1928 fairly sizzled with firsts for women in the state of Texas. They were admitted to the bar and held offices from the Supreme Court to the Governor's Mansion, from city hall to the senate and legislature. As these women candidates seized the opportunity to run, they campaigned on the issues that the reformers had known needed women in office to enact the changes: child labor reform, rural childhood education and colleges and prisons for women. These female officeholders did what the reformers had hoped. They changed the laws and the way Texans would and could operate, providing richer opportunities for women and children and their families.

TEXAS MEN ELECT FIRST FEMALE MAYOR

Birdie Harwood

As she saw it, with her three sons grown, her husband's medical practice thriving and a family legacy of public service, it was her time to serve. Ophelia (Birdie) Harwood tossed her hat into the ring for mayor of Marble Falls in January 1917, three years before women won the right to vote nationally, yet only a year before Texas' women could vote. She surprised local power brokers.

"In casting around for some wide-awake progressive citizen to offer for the office we had not dreamed there was a lady in our midst," said one gentleman, who added, "There is no objection if she can 'deliver the goods.'"

Birdie (Mrs. George) Harwood campaigned hard, buttonholing men on town streets and riding into their fields and pastures to convince them she could do the job, saying, "A woman's first duty is to her home and children: when she has

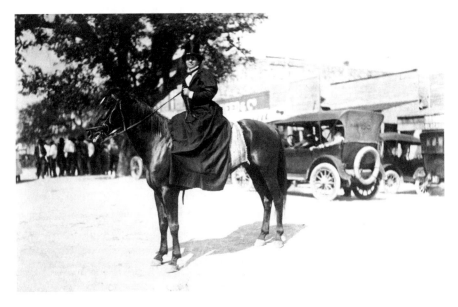

Before women could vote, the men of Marble Falls elected Birdie Harwood mayor, the first woman mayor in Texas and in the United States, on December 2, 1917. In 1919, she led the Armistice Day Parade, riding sidesaddle. President Woodrow Wilson had just signed the law enacting Armistice Day, signaling an end to World War I. *Photo courtesy of The Falls on the Colorado Museum.*

raised them up to take their place in the world, it is then her duty to turn to her State and there help make and enforce the laws that will make it a fit abiding place for them. No good woman is out of place doing those things which are so vital to the welfare of her children and her home."

Either inspired by President Woodrow Wilson or latching on to his embrace of women's suffrage, she quoted the president in her announcement. He had said, "I believe every step in that direction [the right of women to vote] should be applauded."

To her fellow Texans, Birdie Harwood pronounced, "The president of our United States who is recognized all over the world as the grandest man in it today, endorses just this first step I am making in my home town." The Texas legislature would vote for the women's suffrage amendment, the Nineteenth Amendment, the next month.

Birdie challenged her neighbors. "So gentlemen you see Equal Suffrage is widely recognized as one of the great principals of Democracy, and in making this step I am backed by every broadminded, progressive man in our Lone Star State, and in Marble Falls."

Campaigning for "a bigger town, a better town, a cleaner town, and a more progressive town," Birdie championed financial prudence. "We are going to try to make two nickels grow where only one grew before."

She proposed opening the books for public scrutiny and publishing receipts and expenditures in the newspaper. "It is the peoples' money and they should know what becomes of it," she said.

Seventy-nine men voted for Birdie Harwood, thirty-three for the incumbent.

She "delivered the goods." Counted among her accomplishments was a $40,000 bond issue to purchase the water and light plant and secure for Marble Falls "one of the finest water powers in the South." That deal included a twenty-acre tract and a pecan tree–shaded park fronting Marble Falls Lake. Mayor Harwood secured electric lighting for the town and the new public park. Later, she oversaw construction of a bridge to the area spanning the quicksand that had deterred visitors, and she opened the park to camping, establishing Marble Falls' destiny as a resort center.

Her first act as mayor may have been the beginning of Marble Falls becoming the hub of the Hill Country resort area. Men had a bathhouse. Women did not. So Birdie enacted a "law" that women could go to the park to swim but had to wear a robe.

She initiated a "clean-up-the-town day," fulfilling her platform of a cleaner Marble Falls. During her two-year administration, she saw to the lighting of business streets, of purchasing new fire equipment and of moving Marble Falls from town to city status. She carried out her open records pledge.

Birdie retired voluntarily as mayor after two years, but made a stab at returning in 1925, leading an all-woman slate after women could vote. Her slate lost, but her political life was not over.

An all-male commission appointed Birdie Harwood judge of the Municipal Court of Marble Falls at the request of the citizens, an appointment in 1936 that made her proud. Another source of pride for the Johnson City ranch girl, doctor's wife and first woman mayor in the United States was to lead Old Settler's parades dressed in a flowing riding skirt and top hat, mounted on her sixty-five-year-old sidesaddle.

"I am very proud at the age of seventy to represent a womanhood that helped to fight the Indians—while their men made the grandest state in the Union— what it is today. My mother was one of those lovely characters that lived through an epoch that has added much to the luster and glory of our beautiful Texas," she said.

Born in 1872, Mayor Harwood lived until 1954.

First Woman to Win State Office

Annie Webb Blanton

Growing up in Texas' Reconstruction movement with its Old South beliefs that women should stay home, marry and nurture children might have hindered Annie Webb Blanton's life dream to go to college. She intended to attend the University of Texas (UT), the college, which her grandfather helped plan. Her father, a Confederate veteran, though financially comfortable, would not spend the money to send a girl to college.

Born in Houston in 1870, Annie and her family returned to LaGrange when she was nine, after her mother died. Her twin sister died in their teens. Annie's elder sister married and moved away and that left Annie to help rear four younger brothers and sisters.

Teaching had become acceptable work for young women in the late 1880s. At sixteen, Annie moved to Pine Springs, a day's ride away. She taught in a one-room school and fended off proposals from her students, many near her age, because she wanted to attend college.

When her father died the next year, Annie moved her family to Austin to be near her oldest sister and her grandfather. She could teach in the city schools, attend UT and take care of her family.

It took seven years, but she graduated in 1899, two years after a younger brother. Although it is said that she did not resent her brother's easier course, it put wind in Annie's spirit for powering waves of change in Texas' education.

In 1901, she took a job teaching English at North Texas Normal in Denton, the school's first year. The forerunner to today's University of North Texas opened with a faculty of fourteen, eight of them women. When many students could not speak or write proper English, Annie wrote grammar texts that were picked up by schools from Texas to New York. Although North Texas students found her lectures stilted, they honored her with a yearbook dedication in 1908, in "respectful tribute to her justice, impartiality, and interest in the students."

After years of participating in the Texas State Teacher's Association (TSTA), Annie took the floor against tradition. TSTA only allowed men to hold office. Timid about public speaking, she said of that floor speech at the 1916 Fort Worth convention, "I had it in me and when I rose to talk, it came out."

On that day, she spoke. "How long are the functions of the women of the State Teachers' Association to be limited to paying a dollar...of acting as audience and applause...in the future, give us a chance."

Her appeal resulted in her nomination and successful bid for president. In her one-year term, she pushed through resolutions to allow women to be elected to local school boards and to establish the first teacher retirement fund program.

With these ventures into politics, Annie connected with suffragettes and other Progressives. Conflicting with the North Texas Normal President over her political involvement, she resigned, moved to Austin and ran for the state superintendent of schools.

Echoing President Woodrow Wilson's stump for spreading democracy in Europe, justifying World War I, Annie stumped for democracy for white women teachers in Texas.

This was a progressive era in Texas in 1918. Although the women's right to vote, the Nineteenth Amendment, would not be ratified until 1920, state law allowed women to vote in the primary in the one-party state. Annie beat the incumbent in that primary, becoming the first woman to win and hold a state office as state superintendent of schools.

Again she targeted rural education, as she said, "to champion the cause of the children at the forks of the creek, who for two generations have been discriminated against in Texas education."

She established a system of free textbooks, revised teacher certification rules, raised teachers' salaries and improved rural education. In 1920, she proposed the "Better School Amendment" to remove constitutional limitations on tax rates for local school districts. Annie Blanton accomplished these feats in four years.

But in 1922, instead of running for reelection, she ran for Congress and lost.

Back in Austin, she joined the UT faculty, completing her doctorate at Cornell University during summers. Still, her focus remained on rural education, and she set up a rural education department at the university.

Next she founded the educational sorority Delta Kappa Gamma in 1929 to improve standards for the education of teachers and students. While preparing notes for a talk to that organization, Dr. Annie Webb Blanton died in 1945, in Austin.

Teachers nationwide arrived to lay a rose on her casket. Schools are named for her, the first woman elected by Texas voters, who had said, "Everything that helps to wear away age-old prejudices contributes towards the advancement of women and of humanity."

FIRST FEMALE LEGISLATOR

Edith Therrel Wilmans

Born in Louisiana in 1882 but reared in Dallas from the age of three, Edith Therrel Wilmans sought a better life for women of her day, and that of her three daughters. Texas clubwomen had found their voice and their influence, but not yet the right to vote. The causes these women championed addressed problems that disrupted family life—child labor laws, prohibition and prison reform.

As with others, Edith Wilmans realized that the path to lasting change resided in women's right to vote. Social causes like child labor reform were given lip service with toothless laws, so she helped organize the Dallas Equal Suffrage Association, the Dallas Housewives League and the Democratic Women of Dallas County. She presided over the Democratic Women's Association of Texas.

What became her lifelong passion—politics—drove her to study law, and she was admitted to the state bar in 1918. With the passage of the Nineteenth Amendment to the U.S. Constitution, Edith Wilmans ran for the state legislature on the women's vote and with the help of the Ku Klux Klan, which backed women candidates.

In 1922, she won, representing Dallas' District Fifty, the state's first woman legislator. The next year, her husband of twenty-three years died, but she tackled her new work, trying to pass reform legislation. She introduced bills to provide compulsory education, requiring that no child should go to work until after the seventh grade or once they had turned fourteen, and to establish a domestic relations court in Dallas County. She introduced that bill early. Despite a vigorous effort to mobilize women voters, her bill died in the Senate, killed by the man she had beaten. He had become a state senator.

In 1925, the governor appointed Edith to a three-woman panel as the Supreme Court of Texas. She would be associate justice. But she failed to qualify, having practiced law for over six years, but still months shy of the seven-year requirement to serve on the court.

Then Edith raised her sights to take on the senator who had killed her domestic relations court bill. "I'm coming back in two years as the Senator from Dallas. I believe that I will have a better opportunity to serve the women of Texas in the Senate than I would in the House, and for that reason I have about made up my mind to run for the Senate in 1926," she said in January, 1925.

Over the summer, her ambitions changed. She ran for governor and told the League of Women Voters that "woman suffrage is on trial in Texas and that unless women are ably represented suffragette will go backward instead of forward." Her resolution to that problem was campaign reform.

She also advocated prison reform in keeping with the women's organizations: "I believe in some sort of concentration of our prison system…as near Austin as possible. Prisons are for the protection of society and should be used for the purpose of restraining and reforming the criminal and not for punishment."

After that failed election, she ran again in 1928, calling for "radical changes in the methods of caring for the insane" and modernization of the prison system, saying, "It is a serious drain upon the State's treasury…it should be made self-supporting." She also advocated for a highway construction program.

Although she stumped the state on these and other issues—such as flood control, development of natural resources, tax reduction and repeal of the automobile tax—she lost.

Her fame as a female politician, however, drew the notice of a Chicago businessman. She married him in 1929, but the abusive marriage dissolved, and she returned to Dallas in 1933.

Eager for Texas politics, she sought her old House seat, then occupied by another woman. Edith campaigned for tax reform, opposing both a state sales tax and a state income tax, and she opposed liquor sales. "I am both personally and politically dry and if elected shall vote against every attempt to repeal our prohibition statutes," she said. She lost.

The next term, Edith ran again, this time challenging her sister, another Dallas lawyer. Losing in a crowded field of thirty-eight candidates, Edith moved to her farm near Vineyard in Jack County at the age of fifty-two.

But the itch for political office begun in 1922 continued even though the support for women candidates had passed, and she campaigned twice again—during World War II and afterward—losing both. Ten years later, in 1958, she returned to Dallas. Edith Wilmans died in 1966, at the age of eighty-three. One of Dallas' first practicing female attorneys, the state's first woman legislator and a dedicated suffragette, she was survived by three daughters, four grandchildren and eight great-grandchildren.

First Female County Attorney and First Appointed Supreme Court Chief Justice

Nellie Gray Robertson

The flame of women's equality in the law profession flickered and then lay dormant between 1925 and 1982. Before then, though, Nellie Gray Robertson, attractive, smart and strong, would capitalize on the women's suffrage movement and spark a historic moment for Texas.

Nellie Gray Robertson (believed to be on the left) was the first appointed chief justice of the All Women's Supreme Court in 1924. *Photo Credit: C02798 Austin History Center, Austin Public Library.*

Born before the turn of the century—in 1894, to be exact—Nellie Gray Robertson came of age in a generation of women dining on the fruit of the women's suffrage movement. That movement, begun the year before her birth, resulted in women achieving the rights to vote and to hold public office.

A Granbury girl, the sixth of six children whose father left home shortly after her birth, Nellie's young life seems to be characterized by hard work. After graduating from Granbury High School in 1913, she moved to Austin to work her way through the UT law school, graduating and passing the bar in 1918. As one of her sisters-in-law said, "You had to be some kind of tough woman to get through the University of Texas back then."

Female lawyers were rare. The first woman to pass the bar in Texas did so in 1910, just eight years before Nellie.

Returning to Granbury, she owned and operated the Hood County Abstract Company from 1921 to 1926. Branded as "too smart," who never found a man "smart enough to marry," according to her grandfather, Nellie sought public office.

A year after acquiring the abstract company, she ran for and won the office of Hood County attorney, for which Granbury is the county seat. She served from 1922 to 1926, the first female county attorney in Texas.

Two years into her term, another "first" came her way, even if temporary. In 1924, the outgoing governor Pat Neff needed to make some judicial appointments, some "special justices" for the Texas Supreme Court to preside over a civil case in El Paso. The men serving were members of one of the parties in the lawsuit, the Woodmen of the World. The male justices stepped aside, opening a historic door for Governor Neff and female lawyers in Texas.

After checking out the constitutionality of female justices, he appointed Nellie Gray Robertson to preside over a special Supreme Court. In fact, he appointed her to preside as Chief Supreme Court Justice over a three-woman tribunal, a special court for the hearing. According to notes from the time, only about thirty women in Texas served as lawyers since the time in 1910 when the first one passed the bar. Of these, ten met the eligibility requirements. Nellie appeared to be the only one holding elected office, perhaps guiding his choice, despite her youth, to appoint her as "special chief."

"I am in hopes that this recognition of the womanhood of the State as attorneys will be helpful in many ways to those women, wherever they may be, who are fighting single-handed the battle of life," Governor Neff wrote about his appointments of women justices on January 9, 1925.

At thirty-one, with a business and a county office at home, Nellie Robertson decreed that the hearing would be one week later and then shortly afterward stepped aside as not constitutionally eligible for the honor. Some historians cite that she, as did Edith Wilmans, came up months shy of the seven-year requirement of practicing law. Other sources, however, report that she could not hold two offices— county attorney and Supreme Court Special Chief Justice—simultaneously.

Nellie's successor then was the first woman to pass the Texas bar in 1910, Houston lawyer Hortense Ward, who guided the court to a decision that is still cited, most recently in 2003 in San Antonio.

Following the brief fame of her appointment, Nellie and her brother moved to New York City in 1926 to write law books for Doubleday Publishing Company. It was a time in Texas when the women's rights movement declined and entered "a time of disillusionment for women lawyers," recognizing that they were "far from achieving" professional equality with male lawyers, wrote a modern lawyer about that era.

"Later she came back to Beaumont and was head of Stewart Title Company for many years," according to Nellie's sister-in-law.

Nellie Gray Robertson died in 1955, three years before the next wave of successful female jurists led by Sarah Hughes of Dallas who was appointed

Texas district court judge. It took fifty-seven years after the 1925 all-woman court before another woman garnered a Texas Supreme Court appointment in 1982.

Nellie Gray Robertson is buried in Granbury Cemetery.

First Woman Governor Wins Opposing the KKK

Miriam A. (MA) Ferguson

A reluctant candidate at best, one who had shunned the suffragette movement, Miriam A. "MA" Ferguson campaigned to win and served as Texas' governor from 1925 to 1927 and again from 1933 to 1935. Her husband, Jim, had said women belonged in the home. She had agreed, raising their two daughters. But legislators had impeached her husband, and Miriam and Jim wanted the Ferguson name cleared. He put her name on the ticket, and she complied.

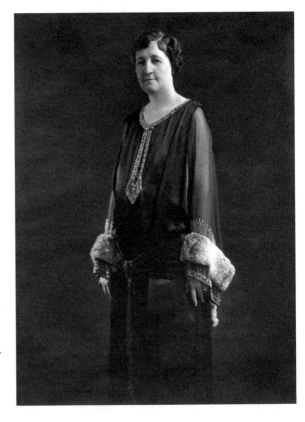

Miriam A. "MA" Ferguson succeeded her husband as governor of Texas, the first woman. Not a suffragette, as many women in her time, Governor Ferguson took more pride in defeating the Ku Klux Klan in her election battle. Being a female governor was not her goal. Her goal was to clear her husband's name and to do so by defeating the KKK, which often supported women candidates. *Courtesy of Texas State Library and Archives Commission.*

Smart and attractive and from a privileged family, Miriam Amanda Wallace Ferguson had gone to school at what became a seat of women making waves and news in the 1920s, Mary Hardin Baylor. She took to the campaign trail at age forty-nine. The suffragettes had defeated her husband, calling for and helping with the investigation that led to his impeachment. Their actions and her run for the office split the women's movement.

She campaigned against the Ku Klux Klan and bootleggers while other suffragettes allied with them in order to win. Winning office with the Ferguson political stronghold in East Texas, Texas' first woman governor got a bill pushed through—with help from her husband's cronyism in the legislature—to unmask the KKK. Later, a judge overruled the bill, but she had struck out at one of her populist, progressive husband's antagonists.

As with most winning officeholders, she put aside differences in order to govern and used her inaugural speech to try to mend some fences. In her opening address to the legislature and the people of Texas, Governor "MA" Ferguson said:

> *As the first woman governor of our beloved state, I ask for the good will and the prayers of the women of Texas. I want to be worthy of the trust and confidence which they have reposed in me…Many women will be invited to an active part in this administration.*
>
> *Let us render full service, not so much because we are women, but because we are Citizens…*

She appointed the state's first female secretary of state, Emma Meharg.

Besides the KKK unmasking law, Governor "MA" Ferguson strived for a balanced budget, advocating in her first term for the taxing of "manufactured cigars and cigarettes," leaving untaxed the tobacco and papers for roll-your-own smokes, and some transportation taxes. In her later term, she called for both a state income tax and a state sales tax. Only the transportation tax passed during her first administration.

In her next term, she pushed through a tax on the oil industry, rolling in state regulation of oil and gas. Also, she legalized betting, another source for state revenue. But budget cuts became the way of meeting Texas' constitutionally required balanced budget in the pre-Depression term and the Depression term.

Prized state institutions, the sacred cows of the time, felt the budget ax. She fired all forty-four Texas Rangers, the famed law enforcement body, because they had voted for her opponent. She replaced those fired with a reduced staff of thirty-two new hires. Even the University of Texas' funds were slashed, especially those for art and journalism classes.

Although she did not lose sight of the need for education, Governor Miriam Ferguson favored programs rather than more buildings while the school systems and colleges clamored for space. Nor did she forget the rural schools, agreeing to budget growth for them as well as the college systems.

Another plank in her platform included prison reform, paralleling calls from the suffragettes. Her way was to pardon. It is said that she pardoned or paroled two thousand state inmates. According to Governor "MA" Ferguson, these inmates had been imprisoned because of alcohol use and abuse and the state needed the beds and the funds for more hard-core prisoners, such as robbers and murderers. Besides, she believed that the burden of the drunkenness arrests fell largely on the poor.

Although reluctant to enter initially and derided by other women, Governor Miriam A. Ferguson must have grown to like the office and what she could do with it. She continued running, winning the two split terms and losing others in 1928, 1937 and 1940. After her husband died, she stopped campaigning and stopped trying to clear his name, though she remained active in Democratic politics in the one-party state. She threw her backing to Lyndon B. Johnson in his race for the U.S. House of Representatives in 1948, remaining on the progressive end of the political continuum.

At a 1955 party to honor Miriam Ferguson's eightieth birthday, then Senate majority leader Lyndon B. Johnson lauded not just Miriam but also her husband as politicians "who stand for the folks—four-square and without apology and no compromise." She lived until June 25, 1961.

The pair of Governor Fergusons, "MA" and Jim, are interred in the State Cemetery in Austin.

PUBLISHER TO STATE SENATOR

Margie Neal

Margie Neal's parents moved from Clayton, a farming community in Panola County, to Carthage so their children could receive a better education. The move imprinted Margie with a zeal for educating the children of Texas, especially rural children.

After graduating from the county's first high school in 1893, she received a scholarship to Sam Houston Normal Institute, where she earned first grade teaching credentials. For the next ten years, she taught in rural, often one-room schools around her home area, Panola County, and then she moved to teach in Forney and Marlin, and finally Fort Worth before her mother's illness called her home in 1903.

Her father purchased the local newspaper, the *Texas Mule* for her to run. She did so but changed the name to the *East Texas Register*. One of the few early female publishers, she championed local, regional and national issues, becoming known as "a progressive editor in a progressive era." She was successful.

Again though, her mother's declining health needed her full attention, and Margie sold the paper in 1912. Yet she continued to support issues such as women's right to vote. She served as secretary of the Panola County Equal Suffrage Association. Then in 1918, when Texas women won the vote, she was the first woman to register in Panola County and became the first female member of the State Democratic Executive Committee. In 1920, when the Women's Suffrage Amendment to the U.S. Constitution was ratified, she attended the Democratic National Convention in San Francisco as a delegate. Her mother died that year.

A new governor appointed Margie the first woman regent for the board overseeing teacher colleges, the State Normal School Board of Regents. During her six years at that post, she strived to improve education by upgrading teaching credentials and succeeded in the selection of Nacogdoches as the site of Stephen F. Austin State Normal College.

Her experience convinced Margie that she could be more effective in the legislature. She won the Texas Senate seat, becoming Texas' first female senator in 1927. She campaigned for better schools, especially rural schools, to improve the state highway system and to improve law enforcement.

In what was called a "clean campaign," she carried four of the five counties. Her seat on the Educational Affairs Committee allowed Margie to push for education.

While trying to upgrade teacher certification by mandating continuing education, she rubbed against the status quo with her bill to end grandfathering. But an amendment was added. Margie voted against her bill. Newspapers chided her lack of knowledge, reporting that she did not know it was her bill.

To those who ridiculed her, she said, "The amendment mutilated my bill so thoroughly that I no longer considered it my own." Her tact, however, was what won her acceptance by fellow senators. "I desire no quarter from the gentlemen because I am a woman."

Other reformers called for a majority of female regents for the College of Industrial Arts, now Texas Women's University, but the state's first woman senator disagreed. "Real equality is better served by letting fitness for the place have as large an influence in the choice of Regents as is possible."

She won that argument and also succeeded in requiring physical education to be a part of the curriculum of public schools.

Aid to country schools to take care of children who lived in Texas' smallest school districts ignited the senator's passion. She saw the appropriation of

$1.6 million for each of the next two years, the largest aid to rural education in Texas' history. The aim was to equalize "the educational opportunities afforded by the state to all children of scholastic age living in small and financially weak school districts." No longer would families have to move so their children could be educated.

As chair of the education committee, Margie pushed for a State Board of Education to supervise Texas' public schools. She believed, a notion born of experience, that education benefited when oversight was not homegrown. Passage of this bill was called "the most progressive step in the history of Texas education."

As a publisher, Marjorie had witnessed the need for an informed citizenry to preserve a strong democracy. She championed requirements that state and federal constitutions be taught in every public school and state college. The bill passed in her second term.

Under her leadership, handicapped children would not be left behind with a measure to establish vocational rehabilitation for them.

By spring of 1933, at fifty-eight, Senator Neal chose not to run for a fifth term. She needed to make some money. The new Roosevelt administration appointed her to the National Industrial Recovery Administration in Washington, D.C., from which she retired eleven years later and returned to Carthage.

Called "a powerful force in community affairs for more than a quarter of a century," Margie Neal died at the age of ninety-six in 1971.

AFTERWORD

Twentieth- and Twenty-first-Century Dames

In the decades of the twentieth century, after the victories of the suffragettes, women's strides in the public sector waned, only to pick up again in the 1940s, when the fellows were off to war. But it would take another two to three decades before women's entry and achievements in the worlds of government, business, medicine and ministry would soar, building on the legacy of these early Texas Dames.

Following in the footsteps of the early aviators, Leoti Clark, a Red Cross volunteer from Wichita Falls, recruited women into a new program, the Women's Airforce Service Pilots (WASPS), which ferried targets, planes and men. While some of these women grew up on the plains and in the greenbelts of Texas, others sallied in from around the country to train and become the female aviators of World War II. Similarly, Sally Ride and Judith Resnik arrived at Houston's NASA, the first and second female astronauts to fly in space in 1983 and 1984, respectively.

A Houston newswoman, Oveta Culp Hobby, organized the Women's Army Corps (WACS) in the wake of Pearl Harbor and served as colonel, commanding her female troops. In 1953, President Dwight Eisenhower called on her to serve as secretary of a new cabinet department—the Department of Health, Education and Welfare. A fellow cabinet member called her "the best man in the cabinet."

In the path of elective political trails blazed by Texas' first mayor, senator, governor and representative came a new generation nearly fifty years later. They took the reins of cities great and small, much as Houston's Kathy Whitmire, in 1982, and Dallas' Annette Straus, in 1987.

Barbara Jordan, though, sought the statehouse three times before winning in 1966, becoming the first black woman in the Texas House of Representatives.

In 1972, she sought and won a seat in the U.S. House of Representatives as a Democrat, another first. Anne Armstrong would become the first woman to address a national political convention when she rallied Republicans in 1972 and then served as a counselor to President Richard Nixon.

Sixteen years later, Ann Richards—Texas' treasurer and third woman to win statewide office, this time in 1982—would take the national pulpit to stoke the fires of the Democratic Convention. In 1990, she went on to win the governorship, sixty-five years after Texas' first female governor, Miriam A. (MA) Ferguson. Three years later, Kay Bailey Hutchison won a special election—followed by subsequent reelections—to serve in the United States Senate, the first woman from Texas.

Building upon the tradition left by that first all-woman Texas Supreme Court in Texas' Progressive era of the 1920s, Sarah Hughes took the oath of office as the state's first female state district judge in 1935. Appointed first, she won successive elections, and President John F. Kennedy named her Texas' first female federal judge in 1961. The national spotlight found her on board Air Force One swearing in Lyndon B. Johnson as president when JFK was slain in Dallas.

Coming forward to the 1980s and 1990s, Marilyn Aboussie of San Angelo presided as chief justice of the Third District Court of Appeals in Austin. In Alpine, Val Beard won the county judge position, the state's first female county judge in Texas' largest county, in area, Brewster County.

Finding a niche in sports—like basketball, track and golf legend Babe Zaharias—would be another woman golfer, Kathy Whitworth from Monahans, the first Ladies Professional Golf Association (LPGA) player to surpass $1 million in career earnings. Her first LPGA victory came in 1962; she retired after her final victory in 1985 with eighty-eight tour victories, the most of any golfer. A member of the Women's Sports Foundation Hall of Fame, she captained the U.S. Solheim Cup team in 1990 and 1992.

Creating a following in entertainment and the arts like Mollie Bailey and her circus would be Dames of song and dance, like Mary Martin of Weatherford, Janis Joplin of Beaumont and Leann Rimes of the Fort Worth–Dallas mid-cities area, bringing prominence to their art, to Texas and to their gender.

Social reform, begun shortly after the Civil War—like Martha McWhirter's women's shelter—would be continued a century later by the likes of Nikki Van Hightower of Houston. Meanwhile, Clara Starr Pope Willoughby of Marshal and San Angelo championed children's causes, resulting in her appointment to the governor's board on criminal and juvenile justice. She served continuously under both Democratic and Republican governors from 1968 to 1985. Although she did not know Jovita Idar, Mary Salinas of Fort Worth shared the same spunk

in her organizing efforts for Mexican Texans with the American Federation of Labor–Congress of Industrial Organizations (AFL-CIO), in the 1950s.

The first woman sheriff in Texas, elected by the people of Loving County, Texas' sparsest in population, was Edna Reed Clayton DeWees in 1945. Four decades after her role-breaking election, Texarkana voters shooed in Mary Choate to wear the star from 1989 to 2000 and Dallas sheriff Lupe Valdez took office in 2005, the first elected female sheriffs in their respective communities. Earlier, by mandate of state law, wives of sheriffs killed in office picked up their husbands' stars until the next election, women like Lulu Seale (1928–1930), of Dallas.

In business, women entrepreneurs have continued to succeed, such as Betty White of San Antonio and Dallas, who broke from the ranks as secretary by inventing correction fluid, today commonly known by the brand names Wite-Out and Liquid Paper. She first manufactured the correcting paint in her garage in 1956 before building an environmental- and family-friendly manufacturing campus in 1968. In 1963, Mary Kay Ash of Hot Wells, Texas, started in Dallas what would become her global cosmetics firm, giving women a chance to work from home and outside the home, their income sealed only by their production, not their gender.

Physicians and scientists widening the path for those who were to come after are women such as Dr. May Owen, pathologist and founding board member of Tarrant County Community College. A Fort Worth doctor from 1921 to 1988, she was voted into the Texas Women's Hall of Fame in 1986. Dr. Alice McPherson specialized in the retina and in 1952 was the only female retina specialist and surgeon in the world. Canadian born, she came to Houston's Baylor College of Medicine in 1959 after a stint where pioneering Dr. Claudia Potter had practiced at Scott & White in Temple. A Flower Mound ranch girl, Dr. Benjy Brooks, headed to Dr. Potter's alma mater, UT Medical School in Galveston in the 1940s. After internships and residencies out of state and in Glasgow, she returned to Texas in 1960 saying, "I feel that I am first a Texan." She became the director of the Division of Pediatric Surgery at the UT Medical School at Houston.

In education, long a fertile target of women's passion, Luce Rede Madrid did not let the Rio Grande become a barrier. She created a lending library and taught children of Texas and Mexico to read and speak English, winning one of President George H.W. Bush's "Thousand Points of Light" awards. That followed a career as a teacher, one of the first Hispanic graduates of Sul Ross State University.

The University of Texas at Austin leaped ahead of its formerly all-male rival, Texas A&M University at College Station, in the promotion of women with Dr. Lorene Rogers' presidency in 1975, a term begun the year before as interim.

Not until Governor Ann Richards appointed Batesville rancher Mary Nan West to the board of regents in 1991 would a woman's hand guide Texas A&M. From 1994 to 1997, she reigned as chair of the university's board.

And while one female minister arrived in Texas in 1885 preaching and writing that women should be allowed to preach, it would be another century before women would be welcomed in Texas pulpits. In keeping with the Reverend Mary's epistles, former journalist and divinity school graduate Reverend Ellen Debenport, of Odessa, came to the pulpit of Unity Church of Dallas, becoming senior minister of the denomination's 1,000-member congregation in 2003.

Perhaps with the groundswell of achievement cast by these modern Texas Dames, the roles of women will not constrict again, as they did after the achievements of the 1920s. Hopefully, Governor Richards's inaugural remarks that addressed equal opportunity in government are true today in all sectors of Texas:

> *Today, we have a vision of a Texas where opportunity knows no race, no gender, no color—a glimpse of the possibilities of what can happen in government if we simply open the doors and let the people in.*
> *—Ann Richards, January 15, 1991*

May the legacy of these and today's Texas Dames continue to enlighten lives and broaden pathways for all women and, perhaps, men as well.

REFERENCES

CHAPTER 1

Bowden, J.J. *Spanish and Mexican Land Grants in the Chihuahuan Acquisition*. El Paso: Texas Western Press, 1971.

Castenada, Carlos E. *Our Catholic Heritage in Texas*. New York: Arno, 1976.

Corbin, Diane H. "Angelina." In *Legendary Ladies of Texas*, edited by Francis Edward Abernathy. Denton: University of North Texas Press, 1994.

Linn, John. *Fifty Years in Texas*. New York: D. & J. Sadlier & Co., 1886. (A facsimile reproduction of original available from Austin, TX: State House Press, 1994.)

Malone, Ann Patton. *Women of the Texas Frontier*. El Paso: Texas Western Press, University of Texas, 1983.

Miles, Elton. *Tales of the Big Bend*. College Station: Texas A&M University Press, 1976.

Murray, Myrtle. "Home Life on Early Ranches of Southwest Texas." *The Cattleman*, June 1939.

Newcomb, Jr., W.W. *The Indians of Texas*. Austin: University of Texas Press, 1961.

———. *The Indians of Texas from Prehistoric to Modern Times*. Austin: University of Texas Press, 1993.

Olbrich, Edith. "Maria Gertrudis Perez Cordero Cassiano, (1790–1832)." In *Women in Early Texas*, edited by Evelyn M. Carrington. Austin: Texas State Historical Association, 1994.

Tyler, Ronnie C., Douglas E. Barnett and Roy R. Barkley, eds. *The New Handbook of Texas*. Austin: Texas State History Association, 1996.

CHAPTER 2

Alexander Family Papers. "A Monograph of the life of Mrs. Mary Jane Alexander." Amarillo, TX: Panhandle Plains Museum, n.d.

Austin Colony Papers, 3 volumes: 1,499–1,577; 1,630–1,631. Austin: The Collections by The Center for American History, The University of Texas at Austin, 1826–1827.

Cartier, Robert R., and Frank Hole. *San Jacinto Battleground Archeological Studies: History of the McCormick League and Areas Adjoining the San Jacinto Battleground.* Austin: Antiquities Committee of the State of Texas, 1971–72.

Crawford, Ann Fears, and Crystal Sasse Ragsdale. "'Trials and Troubles in Texas:' Mary Crownover Rabb." In *Women in Texas.* Austin, TX: Eakin Press, 1982.

Deed Registries, Republic of Texas, Red River County, Books A&B. Nacogdoches County.

Deeds, Civil and Criminal Court Records. Republic of Texas. Houston Public Library, Regional History. 1836–1848.

DeShields, James T. *Border Wars of Texas.* Austin, TX: State House Press, 1993.

Edward, David B. *The History of Texas, Or, the Emigrant's, Farmer's, and Politician's Guide to the Character, Climate, Soil and Productions of That Country.* Austin: Texas State Historical Association, 1990. Originally published: Cincinnati: J.A. James, 1836.

Foremen, Caroline. "A Creek Pioneer." *Chronicles of Oklahoma* 21 (September 1943).

Francaviglia, Richard V. *From Sail to Steam, Four Centuries of Texas Maritime History, 1500–1900.* Austin: University of Texas Press, 1998.

Guthrie, Keith. *Texas Forgotten Ports, Vol. II.* Burnet, TX: Eakin Press, 1993.

Hagerty Papers and Legal Documents. Austin: The Center for American History, University of Texas.

Harris County Historical Society. *Houston: A Nation's Capital, 1837–1839.* Houston, TX: D. Armstrong Co., 1985.

Haynes, Michaele Thurgood. "Mary Ann (Molly) Dyer Goodnight" In *Texas Women on the Cattle Trails.* Edited by Sara Massey. College Station: Texas A&M University Press, 2006.

Houston, Andrew Jackson. "Map of the San Jacinto Battlefield Featuring Tory Hill." Austin: The Center for American History, The University of Texas,1938.

Land Records. Texas State Library and Archives, Austin.

Looscan, Adele B. "Harris County 1822–1845." Austin: Texas State Historical Association. Reprint from Southwestern Historical Quarterly 18 (October 1914).

Marshall News-Messenger. August 25, 1974.

McArthur, Judith N. Fall. "Myth, Reality, and Anomaly: The Complex World of Rebecca Hagerty." *East Texas Historical Journal* 24 (1986).

Moss, A. Henry. Papers. University of Texas Archives, Box 2f74.

MS McCormick File. LaPorte, TX: San Jacinto Museum of History.

Neely, Lisa A. "Estelle Amanda Nite Burks." In *Texas Women on the Cattle Trails.* Edited by Sara Massey. College Station: Texas A&M University Press, 2006.

Pickle, Joe. Author interview, March 4, 2000.

"Republic Claims—McCormick, Margaret & McCormick, Mike (Pension Claims)," Nos. 7003, 32, Reels 66 and 228. Texas State Library and Archives Commission, Austin.

Roberts, Dora. Family papers and author interviews. Big Spring, TX: Heritage Museum of Big Spring. 2000.

———. Papers. Lubbock, TX: Southwest Collection/Special Collections Library, Texas Tech University.

Robertson, Pauline, and R.L. *Panhandle Pilgrimage.* Amarillo, TX: Paramount Publishing, 1976.

Rogers, Mary Beth, Sherry A. Smith and Janelle D. Scott. *We Can Fly*. Austin: Ellen C. Temple Publisher, 1983.

"Smith, Ashbel Papers." The Collections by The Center for American History, The University of Texas at Austin.

Sowell, A.J. *Rangers and Pioneers of Texas*. Austin, TX: State House Press, 1991.

Texas Sheep and Goat Raisers Association. "Prominent West Texas Woman Buried at Menard." 1921.

Tyler, Ron, Douglas E. Barnett, and Roy R. Barkley, eds. *The New Handbook of Texas*. Austin: Texas State Historical Association, 1996.

Wilhelm family papers and interview with Clara Porter (great-great-granddaughter), 2005.

Wilhelm Papers. Lubbock, TX: Southwestern Collection, Special Collections Library, Texas Tech University.

Wooster, Ralph A. "Wealthy Texans, 1860." *Southwest Historical Quarterly* 65 (July 1961).

CHAPTER 3

Carrington, Evelyn M., and Elsie Turk Smothers, eds. *Women in Early Texas*. Austin, TX: AAUW-Austin Branch, 1994.

Clayton, Lawrence. *Historic Ranches of Texas*. Austin: The University of Texas Press, 1993.

Exley, Jo Ella Powell, ed. *Texas Tears and Texas Sunshine*. College Station: Texas A&M University Press, 1985.

Ford, John S. *Rip Ford's Texas*. Edited, and with commentary by Stephen B. Oates. Austin, TX: University of Texas Press, 1885.

Goldfinch, Charles W., and Jose T. Canales. *Juan Cortina: Two Interpretations*. New York: Arno Publications, 1974.

Graham, Don. *Kings of Texas*. Hoboken, NJ: John Wiley & Sons, 2003.

Helm, Mary Sherwood. *Scraps of Early Texas History*. Austin: privately printed, 1884.

Jarvis, Mrs. Ida Van Zandt. "Mrs. Isaac Van Zandt," Fort Worth.

King, C. Richard. *The Lady Cannoneer*. Burnet, TX: Eakin Press, 1981.

Murray, Myrtle. "Home Life on Early Ranches of Southwest Texas." *The Cattleman*, June 1939.

Pickrell, Annie Doom. *Pioneer Women in Texas*. Austin, TX: State House Press, 1991

Smothers, Elsie Turk. "Margaret Hallett, (1787–1863)." In *Women in Early Texas*. Edited by Evelyn M. Carrington, Austin, TX: Texas State Historical Association, 1994.

Tyler, Ron, Douglas E. Barnett and Roy R. Barkley, eds. *The New Handbook of Texas*. Austin: Texas State Historical Association, 1996.

Van Zandt, Frances Cooke Lipscomb. "Reminiscences of Frances Cooke Lipscomb Van Zandt." Fort Worth: 1905. Reproduced, Fort Worth: Louise Burgess Logan, 1973.

CHAPTER 4

Abernathy, Francis Edward, ed. *Legendary Ladies of Texas*. Denton: University of North Texas Press, 1994.

Brown, John Henry. *Indian Wars and Pioneers of Texas*. Austin, TX: L.E. Daniel Publisher, 1880.

Carrington, Evelyn M., Ed. *Women in Early Texas*. Austin, TX: American Association of University Women, 1994.

Day, James M. "Early Settlers and their Domestic, Social and Other Activities." In *Texas Almanac, 1857–1873. West Texas Frontier, Vol.1.* Jacksboro, TX: 1933.

DeShields, James T. *Border Wars of Texas*. Austin, TX: State House Press, 1912, reprint 1993.

Douglas, C.L. *Cattle Kings of Texas*. Austin, TX: State House Press, 1989.

Eckhardt, C.F. *Tales of Bad Men, Bad Women, and Bad Places*. Lubbock, TX: Tech University Press, 1999.

Guthrie, Keith. *Texas Forgotten Ports, Vol. II.* Austin, TX: Eakin Press, 1993.

Harris County Historical Society. *Houston: A Nation's Capital, 1837–1839*. Houston, TX: D. Armstrong Co., 1985.

History of Parker County. Weatherford, TX: Parker County Historical Commission, 1980.

Holden, Frances Mayhugh. *Lambshead Before Interwoven: A Texas Range Chronicle, 1848–1878*. College Station: Texas A&M University Press, 1981.

Holland, Gustavus Adolphus. *History of Parker County and the Double Log Cabin*. Weatherford, TX: Herald, 1931.

Hollon, W. Eugene, Ed. *William Bollaert's Texas*. Norman: University of Oklahoma Press, 1956.

Kilgore, Dan. "Two Six-shooters and a Sunbonnet: The Story of Sally Skull." In *Legendary Ladies of Texas*. Edited by Francis E. Abernethy. Denton: University of North Texas Press, 1981.

Knight, Oliver. *Fort Worth: Outpost on the Trinity*. Fort Worth: Texas Christian University Press, 1990.

Lack, Paul D. *The Texas Revolutionary Experience*. College Station: Texas A&M University Press, 1996.

Ledbetter, Barbara A. Neal. *Fort Belknap Frontier Saga: Indians, Negroes and Anglo-Americans on the Texas Frontier.* Burnet, TX: Eakin Press, 1982.

Linn, John. *Fifty Years in Texas*. New York: D. & J. Sadlier & Co. 1886. Fascimile Reproduction of Original, Austin, TX: State House Press, 1986.

Malone, Ann Patton. *Women on the Texas Frontier, a Cross-Cultural Perspective. Southwestern Studies, Vol. 70*. El Paso: Texas Western Press, University of Texas at El Paso, 1983.

Matthews, Sallie Reynolds. *Interwoven: A Pioneer Chronicle*. College Station: Texas A&M University Press, 1936.

McLeRoy, Sherrie S. *Red River Women*. Plano: Republic of Texas Press, 1996.

Murray, Myrtle. "Home Life on Early Ranches of Southwest Texas." *The Cattleman*, June 1939.

Strickland, Rex. "Anglo-American Activities in Northeast Texas, 1803–1845." Unpublished dissertation.

Tolbert, Frank X. *The Day of San Jacinto*. New York: McGraw-Hill, 1959.

Turner, Martha Anne. "Emily Morgan, Yellow Rose of Texas." In *Legendary Ladies of Texas*. Nacogdoches: Texas Folklore Society, 1981. Reprint, Denton: North Texas State University Press, 1994.

―――. *The Yellow Rose of Texas: Her Saga and Her Song*. Austin, TX: Shoal Creek Publishers, 1976.

Tyler, Ron, Douglas E. Barnett and Roy R. Barkley, eds. *The New Handbook of Texas*. Austin: Texas State Historical Association, 1996.

Wilbarger, J.W. *Indian Depredations in Texas*. Austin, TX: Hutchings Printing House, 1889.

CHAPTER 5

Brady, Mrs. Sue Huffman. "Changing Ideals in Southern Womanhood." In *The Congress of Women*. Edited by Mary Eagle. Chicago: Ayer Company Publishers, 1894.

Brooks, Elizabeth. *Prominent Women of Texas*. Akron, OH: Werner Co., no date.

Clark, Joseph Linn. *Thank God We Made It! A Family Affair with Education*. Austin: The University of Texas, 1969.

Clark, Randolph. *Reminiscences of Randolph Clark*. Wichita Falls: Lee Clark Publisher, 1919.

Crawford, Ann Fears, and Crystal Sasse Ragsdale. *Women in Texas*. Burnet: Eakin Press, 1982.

Crutcher, Mary. "Sue Huffman Brady." *Fort Worth Press*, September 6, 1939.

Dallas Morning News. "Universalists Convention the First day's Proceedings." March 19, 1887.

DeSpain Log. Genealogical tracts.

Downs, Fane. "Tryels and Trubbles: Women in Early 19th Century Texas." *Southwestern Historical Quarterly* 90, no. 1 (July 1986): 35–56.

Eckerman, Jo. "Artemisia Bowden: Dedicated Dreamer." *Passages: The University of Texas Institute of Texan Cultures at San Antonio* 2 (Winter 1987).

Goetting, Mrs. Charles A. "Tribute to Olga Bernstein Kohlberg." *Passages: The University of Texas Institute of Texan Cultures at San Antonio* 17, 1972.

Hunt, Sylvia. "'Throw Aside the Veil of Helplessness:' A Southern Feminist at the 1893 World's Fair." *Southwestern Historical Quarterly*, July 1996.

Leonard, John William, ed. "Kohlberg, Olga Bernstein." In *Woman's Who's Who of America*. New York: American Commonwealth, 1914.

"Mary Sue Huffman (later–Warren, Brady)." Student biographical card. Huntsville, TX: Sam Houston State University Library.

"Olga Kohlberg." *El Paso Historical Society's Password*, Winter 1972.

Paschal, R.L. "Miss M. Sue Huffman, Early Fort Worth Educator." *Fort Worth Star Telegram*, November 26, 1939.

Rabb, Mary Crownover. "Tryals and Trubles." In *Texas Tears and Texas Sunshine, Voices of Frontier Women*. Edited Jo Ella Powell Exley. College Station: Texas A&M University Press, 1990.

"Texas Association of the Universalist Church Organized on the 24th day of Sept. 1886 at the call of the Rev. James Billings, the Texas State Missionary." Minutes and records. 1886.

Tyler, Ron, Douglas E. Barnett and Roy R. Barkley, eds. *The New Handbook of Texas*. Austin: Texas State Historical Association, 1996.

Unitarian Universalist Ministers File. Andover-Harvard Theological Library, Harvard Divinity School.

Winegarten, Ruthe, and Cathy Schechter. *Deep in the Heart: The Lives and Legends of Texas Jews*. Austin, TX: Eakin Press, 1990.

CHAPTER 6

Cleveland Gazette. "Hope Thompson." October 23, 1886.

Cockrell Family Papers A20002.335. Dallas, TX: DeGolyer Library, Southern Methodist University.

Crawford, Ann Fears, and Crystall Sasse Ragsdale. *Women in Texas*. Burnet, TX: Eakin Press, 1982.

Dallas Times Herald. "Ex Slave's Property Enjoyed Dallas Boon." August 25, 1949.

Dallas Weekly Herald. "Hope Thompson." January 30, 1875.

Gibbs Brothers papers. Sam Houston Museum.

Greene, A.C. Dallas: *The Deciding Years—A Historical Portrait*. Austin, TX: Encino Press, 1973.

Meyer, Marion. *Mary Donoho: New First Lady of the Santa Fe Trail*. Santa Fe, NM: Ancient City Press, 1991.

Rogers, Mary Beth, Sherry A. Smith and Janelle D. Scott. "Savior of the Alamo, Clara Driscoll." In *We Can Fly*. Austin, TX: Ellen C. Temple Publisher, 1983.

Thompson, Hope. Case no. 4493, W.C. Putty vs. Hope Thompson, Case no. 1317, District Court of Dallas County, 1888.

Tyler, Ron, Douglas E. Barnett and Roy R. Barkley, eds. *The New Handbook of Texas*. Austin: Texas State Historical Association, 1996.

Walker, Donald. *A Frontier Texas Mercantile: The History of Gibbs Brothers and Company, Huntsville, 1841–1940*. Huntsville, TX: Texas Review Press, 1997.

York, Elizabeth. "Opportunity Versus Propriety: The Life and Career of Frontier Matriarch Sarah Horton Cockrell." *Frontiers: A Journal of Women's Studies* 6, no. 3 (Fall 1981):106–114.

Zellar, Gary. "Mrs. Sallie E. Gibbs, 1844–1918." Huntsville, TX: City of Huntsville Cultural Services Division.

CHAPTER 7

Armstrong, Dr. Mollie. Her biographical notes, dates of major events. Brownwood Public Library.

Bieniek, Alexia Hueske. "The Story of Dr. Mollie Armstrong the First Woman Optometrist in Texas." Unpublished paper.

Bonta, Marcia Myers. "Mary Sophie Young." In *American Women Afield, 1872–1919*. College Station: Texas A&M University Press, 1995.

Brownwood Bulletin. "Mollie Armstrong Rites Set." May 24, 1964.

Creighton, James A.A. *A Narrative History of Brazoria County*. Angleton, TX: Brazoria County Historical Commission, 1975.

Gillespie, Dr. and Mrs. "Career of Dr. Claudia Potter." Temple: Scott & White Hospital video tape interview.

"Katherine & Marjorie Stinson, Pioneer Aviatrices." In *The Pioneers, Aviation and Aeromodelling–Interdependent Evolutions and Histories*. Washington, D.C.: National Air and Space Museum, Smithsonian Institution. 2000.

Pettey, Weston A. *Optometry in Texas, 1900–1984*. Austin, TX: Nortex Press, division of Eakin Press, 1985.

Rogers, Mary Beth, Sherry A. Smith and Janelle D. Scott. "The Daring Doctor of Brazoria: Dr. Sofie Herzog, 1848–1925." In *We Can Fly*. Austin, TX: Ellen C. Temple Publisher, 1983.

———. "The Flying Shoolmarm: Marjorie Stinson, 1896–1975." In *We Can Fly*. Austin, TX: Ellen C. Temple Publisher, 1983.

Smith, Angeline. "She Helped World to See." *Brownwood Bulletin*, October 19, 1959.

Texas Journal of Optometry. "A Living Legend Passes, Dr. Mollie Armstrong Is Gone." May 1964.

Tharp, B., and Chester V. Kielman. "Mary S. Young's Journal of Botanical Explorations in Trans-Pecos Texas, August–September, 1914." *Southwestern Historical Quarterly* 65 (January, April 1962).

Tyler, Ron, Douglas E. Barnett and Roy R. Barkley, eds. *The New Handbook of Texas*. Austin: Texas State Historical Association, 1996.

CHAPTER 8

Crawford, Anne Fears, and Crystal Sasse Ragsdale. "I Have Books I Must Write, Dorothy Scarborough." In *Women in Texas*. Burnet, TX: Eakin Press, 1982.

———. "Sculptress of Statesmen, Elisabet Ney." In *Women in Texas*. Burnet, TX: Eakin Press, 1982.

Crider, Sylvia Ann, and Lou Halsell Rodenberger. *Texas Women Writers*. College Station: Texas A&M University Press, 1997.

Dondoneau, Dave. "Blazing a Path." *Fort Worth Star Telegram*, April 25, 1999.

———. "The Female Babe: A Driven Wonder." *Fort Worth Star Telegram*, December 1, 1999.

Hartzong, Martha. "Mollie Bailey: Circus Entrepreneur." In *Texas Legendary Ladies*. Edited by Francis Edward Abernethy. Nacogdoches: Texas Folklore Society 1981. Reprint, Denton: University of North Texas Press, 1994.

Johnson, Thad S., with Louis Didrikson. *The Incredible Babe, Her Ultimate Story*. Lake Charles, LA: Andrus Printing and Copy Center, 1996.

Nye, Mary E. "Elisabet Ney: Texas' First Lady of Sculpture." In *Texas Legendary Ladies*. Edited by Francis Edward Abernethy. Nacogdoches: Texas Folklore Society, 1981. Denton: University of North Texas Press, 1994.

Pate, W.L., Jr., president of Babe Didrikson Zaharias Foundation. Author interview. 2005.

Roberta Dodd papers. Sam Rayburn Museum, Bonham, TX.

Seligman, Claudia Dee. *Texas Women Legends in Their Own Times*. Dallas, TX: Hendrick-Long Publishing, 1944.

Tyler, Ron, Douglas E. Barnett and Roy R. Barkley, eds. *The New Handbook of Texas*. Austin: Texas State Historical Association, 1996.

Winegarten, Ruthe. "Elisabet Ney." In *Governor Ann Richards & Other Texas Women, from Indians to Astronauts.* Austin, TX: Eakin Press, 1986.

CHAPTER 9

Bell County Historical Museum. Martha McWhirter and the Belton Woman's Commonwealth.

Cottrell, Debbie. *Pioneer Woman Educator: The Progressive Spirit of Annie Webb Blanton*. College Station: Texas A&M University Press, 1993.

Downs, Fane, and Nancy Baker Jones. *Women and Texas History*. Austin: Texas State Historical Association, 1993.

James, Eleanor. "Martha White McWhirter (1827–1904)." In *Women in Early Texas*. Edited by Evelyn Carrington. Austin: Texas State Historical Association, 1994.

Jones, Nancy Baker. "Jovita Idar." In *The New Handbook of Texas*. Edited by Ron Tyler, et al. Austin: Texas State History Association, 1996.

Rogers, Mary Beth, Sherry A. Smith and Janelle D. Scott. "Civil Rights Crusader Christia Adair." In *We Can Fly*. Austin, TX: Ellen C. Temple Publisher, with Texas Foundation for Women's Resources, 1983.

————. "Women of a Revolution, Jovita Idar, Leonor C. Villegas de Magnon." In *We Can Fly*. Austin, TX: Ellen C. Temple Publisher, with Texas Foundation for Women's Resources, 1983.

Tyler, Ron, Douglas E. Barnett and Roy R. Barkley, eds.. *The New Handbook of Texas*. Austin: Texas State Historical Association, 1996.

Werden, Frieda. "Martha White McWhirter and the Belton Sanctificationists." In *Legendary Ladies of Texas*. Denton: Texas Folklore Society, University of North Texas Press, 1994.

Winegarten, Ruthe. *Governor Ann Richards & Other Texas Women*. Austin, TX: Eakin Press, 1986.

Winegarten, Ruthe, and Judith N. McArthur. *Citizens at Last: The Woman Suffrage Movement in Texas*. Austin, TX: Ellen C. Temple Publisher, 1987.

Yelderman, Pauline. *The Jay Bird Democratic Association of Fort Bend County*, Waco, TX: Texian Press, 1979.

CHAPTER 10

Crawford, Ann Fears, and Crystal Sasse Ragsdale. "'Me for MA' Governor Miriam Amanda Ferguson." In *Women in Texas*. Austin, TX: State House Press, 1982.

Cunningham, Patricia Ellen. "Bonnet in the Ring: Minnie Fisher Cunningham's Campaign for Governor of Texas in 1944." In *Women and Texas History*. Austin: Texas State Historical Association, 1944.

Dallas Morning News. "Domestic Court Bill Unfavorably Reported." February 21,1923.

———. "Former Edith Wilmans, Given Divorce in Chicago." 1930.

———. "Klan Candidates Hold Safe Leads." July 24, 1922.

———. "Mrs. Wilmans, True to Her Sex, Has the Last Word at Session." March 16, 1925.

———. "Mrs. Wilmans Dies; Was Once Legislator." March 22, 1966.

———. "Mrs. Wilmans to Seek Senatorship." January 19, 1925.

———. "Mrs. Wilmans Would Amend Primary law." September 25, 1925.

———. "Slim Voter Interest Shown in 13th Congress." June 27, 1948.

Ferguson, Miriam "MA." "Keep within State Income." Inaugural address reported in *Granbury News*, January 6, 1925.

Granbury News. "Ask for Restoration of James E. Ferguson." February 28, 1925.

Harris, Walter L. "Margie E. Neal: First Woman Senator in Texas." *East Texas Historical Journal*, Spring 1973.

Marble Falls Messenger. "Mrs. George Harwood Candidate for Mayor." January 25, 1918.

———. "Why I Am Running for Mayor of Marble Falls." (before March 15 issue, 1917).

McAfee, Alice G. "The All Woman Texas Supreme Court: The History Behind A Very Brief Moment on the Bench." From the *Selected Works of Alice G. McAfee*. Works.bepress.com/alice_mcafee. 2007.

McSpadden, Fran. Harwood/Crosby family notes/interview, October 29, 2004. Falls on the River Museum.

Paulissen, Maisie. "Pardon Me, Governor Ferguson." In *Legendary Ladies of Texas*, Francis Edward Abernathy, ed. Nacogdoches: Texas Folklore Society, 1981.

Picayune. "Birdie Harwood Day." July 20, 1993.

Tyler, Ron, Douglas E. Barnett and Roy R. Barkley, eds.. *The New Handbook of Texas*. Austin: Texas State Historical Association, 1996.

Wharton, Clarence R., ed. *Texas Under Many Flags: Texas Biography*. Chicago: American Historical Society, 1930.

Winegarten, Ruthe. *Governor Ann Richards & Other Texas Women*. Burnet, TX: Eakin Press, 1986.

Winegarten, Ruthe, Mary Beth Rogers and Sherry Smith. *Texas Women: A Celebration of History*. Austin, TX: Foundation for Women's Resources, 1981.

INDEX

About the Author

A seventh-generation Texan, storyteller Carmen Goldthwaite applied shoe leather journalism to find the Texas Dames stories, a fascination triggered by family tales. Earlier awards for investigative reporting led to her syndication with Scripps Howard News, and she continues her membership in Investigative Reporters and Editors and the Society of Professional Journalists. After reporting, she turned to writing Texas history for western history magazines and anthologies and sailing news, her hobby. An essay honoring her mother, the family storyteller, appeared in *Chicken Soup for the Soul: The Magic of Mothers and Daughters* (2012). Carmen enjoys membership in the Texas State History Association, Westerners International and Western Writers of America. She lives in Fort Worth, Texas, her hometown.

Visit us at
www.historypress.net